Drawing Portraits

FACES AND FIGURES

Giovanni Civardi

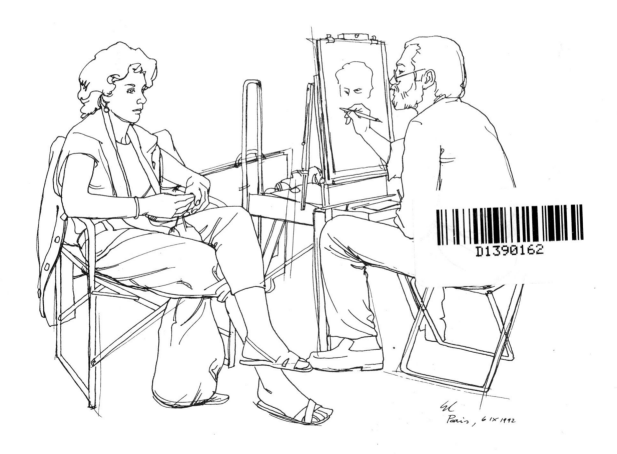

Paris, 6 IX 1992

SEARCH PRESS

First published in Great Britain 2002 by Search Press Limited,
Wellwood, North Farm Road, Tunbridge Wells, Kent TN2 3DR

Reprinted 2004, 2005, 2006, 2007

Originally published in Italy 1994 by Il Castello Collane Tecniche,
Milano

Copyright © Il Castello Collane Tecniche, Milano 1994

English translation by Julie Carbonara

English translation copyright © Search Press Limited 2002

ISBN 10: 1 903975 09 3
ISBN 13: 978 1 903975 09 1

Design by Grazia Cortese

The portraits in this book were done with the models' agreement:
any resemblance to other people is incidental.

Printed In Malaysia

INTRODUCTION

A portrait is commonly perceived as the representation of a human being's features, whether the face, head and shoulders or the whole body. It has always been an important theme in figurative arts and a favourite with artists, who have found in it, not just a professional genre well rewarded and socially appreciated for its symbolic or celebratory value, but also an interesting opportunity to investigate the human condition in its physical and, most of all, psychological aspect. It is this latter aspect which tends to predominate nowadays, as photography has greatly undermined the function of the drawn and painted portrait as the only way to reproduce and hand down for posterity an individual's physiognomic features. But this 'documentary' aspect was, of course, only one of the features of the artistic portrait.

Using my experience as a portrait painter, illustrator and teacher, I have tried to simplify and sum up the main problems one usually comes across when first tackling a 'generic' head drawing and, subsequently, an actual portrait or likeness. Some subjects of particular importance, e.g. drawing hands, portraits of children and elderly people, the full figure portrait, and heads with unusual features have to be dealt with in more detail and are covered in more advanced books.

I have divided the short chapters and the accompanying sketches according to a sequence which I have found of practical help in teaching the rudiments of portrait 'technique'. I have found this approach quickly leads to satisfying results. The book covers tools, techniques, practical considerations, anatomy, details of the face, composition, lighting and actual method, stressing the 'overall' view of the head.

These basic technical principles can only direct you in your first experiences and should be seen as suggestions on which to build your own study. Your subsequent artistic development will depend on how committed you are to observation and how regularly you practise drawing. To this purpose, you can, when you approach your first drawings resort to observing drawings done by other artists and taking photographs of your subject. However, as soon as you feel confident in sketching the basic outlines of the head, I advise you to try and draw from life, getting a patient friend to sit for you. In the last section of this book I have put together some portrait studies which I have drawn at different times and which give an indication of how to go about tackling different subjects.

TOOLS AND TECHNIQUES

You can draw a portrait using any of the popular media: pencil, charcoal, pastel, pen and ink, watercolour, felt-pen, etc. Each one of them, however, will produce different effects, not only due to the specific characteristics of the medium and the technique used, but also in relation to the characteristics of the surface on which it is drawn: smooth or rough-textured paper, card, white or coloured paper, etc. The drawings shown on these two pages demonstrate how different media effectively render the complex tonal values of the human face and body.

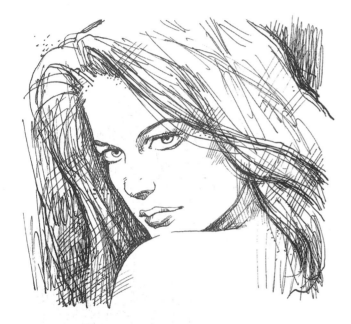

Pen and black Indian ink on smooth paper

Ink is widely used by artists. It can be applied either with a brush or with a pen, but special effects can be achieved using bamboo reeds, large nibs, fountain pens, technical pens, felt-pens, or ball-point pens. Tones can usually be graded by drawing more or less dense lines over one another at right angles (cross-hatching). It is advisable to draw on smooth, good quality paper or card, so that the surface won't fray or absorb ink irregularly.

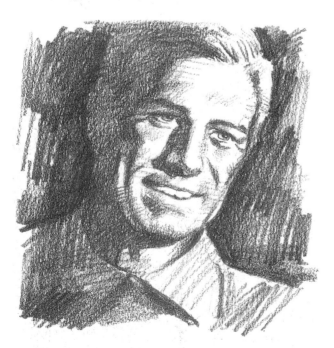

Pencil (B and 2B) on rough-textured paper

Pencil is the most widely used medium for any type of drawing and, in figures and portraits, it allows you to be spontaneous and is convenient to use. It can be used for very complex drawings or for small studies and quick reference sketches: for the latter very fine leads are suitable, while for the former you can use thicker and softer-grade graphites. Graphites (leads that are held in mechanical, clutch pencils) as well as pencils (wood-encased graphites) are graded according to their consistency: from 9H, the hardest, which traces thin and faint lines, to 6B, very soft, which traces thick and dark lines with ease.

Compressed charcoal on paper

Charcoal is perhaps the ideal medium for portrait study as it is very easy to control when applying tones but also allows you to achieve fairly sharp detail. It should, however, be used 'broadly', concentrating on the overall rendering of the 'shapes': this exploits its greatest assets, as it is both versatile and evocative. You can use either compressed charcoal or willow charcoal but be careful, in either case, not to smudge the sheet. Charcoal strokes can be blended and smudged by gently rubbing with a finger, and tones can be softened by blotting with a soft eraser (kneadable putty eraser). The finished drawing should be protected by spraying with fixative.

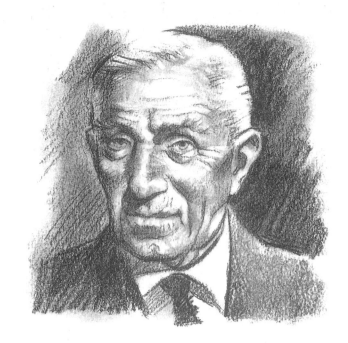

Monochromatic watercolour on medium-textured paper

Watercolours, water-soluble inks, and water-diluted Indian ink are ideal for portrait study, although they are closer to painting than to drawing, as they are applied with a brush and require a tonal vision which is both concise and expressive. For quick studies you can use water-soluble graphites or colour pencils (to blend strokes easily, wipe them with a water-soaked brush) and it is advisable to use heavy card so that the moisture will not cause the surface to cockle and become irregular.

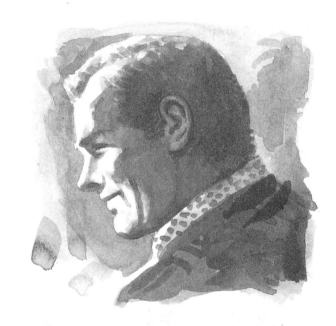

Pen and ink, watercolour, white pastel on coloured paper

'Mixed' media involves using different materials to achieve a drawing with unusual effects. Although still 'graphic' materials, their more complex application requires good control and a good knowledge of the media themselves if we are to avoid muddled results of little aesthetic meaning. Mixed media are very effective on textured and coloured, or dark, supports.

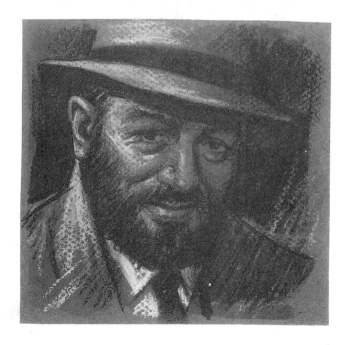

PRACTICAL ADVICE

It is useful to outline very briefly some advice on portrait 'practice'. In the subsequent chapters some of these subjects will be developed with the help of diagrams and graphic examples.

TYPES OF PORTRAIT

Given the great variety of poses a human being can take on and the psychological wealth which characterizes every personality, the artist has to assess what 'pose' to suggest to the model so that these elements are displayed in the most suitable way to achieve a likeness.

In addition, all individuals have their own characteristic posture and typical movements which are part of their 'being'. On the other hand, there are elements of physical behaviour and social convention which allow us to place the subject in the profession and 'status' they belong to or aim for. One can therefore differentiate between two types of portrait: 'formal', where the subject's pose follows traditional patterns, and where a lot of attention is paid to composition, the environment and the, at times symbolic, décor; and 'informal', where the model's pose is spontaneous as he or she is captured in a casual pose or while carrying out some regular activity in a normal environment. It is an effective and modern way of portraying people which is a legacy of 'instant' photography and requires a lot of skill and good taste from the artist. To this category belong also 'expressive' portraits, that is those where the subject is, for instance, caught smiling or in motion.

FRAMING

Whatever type of portrait, you need to choose how to represent the subject. You can, in fact, draw just the head (or part of the face) or the whole figure. To make the portrait more expressive it can be useful to draw just part of the body including, for instance, not just the head but also the shoulders, the torso and the hands. Draw a lot of sketches to find the best pose (see page 24) and a composition which is effective, well balanced, and not monotonous. Avoid dispersing the visual interest of the viewer and bear in mind that the focal point will have to be the face and, above all, the eyes. Note that the hands can be as expressive as the face, because of their 'movement', as well as their shape and their role in the composition. Therefore, if you think your model's hands have character, do not hesitate to include them in the drawing.

SUBJECTS

To portray a human being you need not just to be able to capture and draw their features, but also to hint at the character and the mood of the model: this encapsulates the artistic quality of a portrait. I thought it useful to include some advice specific to the different types of subjects you will often draw. Always obtain from your subject permission to portray them or, if need be, to exhibit the drawings you have done.

Children (See page 47). A child's head is proportionally bigger than that of an adult, especially in the skull which is far bulkier than the face. Eyes and ears look big but the nose is small and upturned; the bone structure is minute and the jaw rounded. Drawing children is difficult because they are restless and don't like being watched. In many instances you will find a photograph taken by surprise to avoid 'grimaces', useful. Children's delicate features need weak and diffused lighting: strong artificial light or direct sunlight create strong shadows which may alter the physiognomy and cause them to half-close their eyes.

Women In portraits of women, as well as searching for the subject's personality there is also a tendency to enhance the aesthetic aspect. Choose informal poses, spontaneous if the subject is young or more austere and serene if she is more mature. Avoid, however, affected or excessively 'theatrical' poses. In many cases you will find it useful to draw the whole figure so that clothes and background can help to convey the subject's personality.

Men The male portrait was traditionally more formal, representing an 'official' image linked not just to the subject's physical features, but also to their social standing. Sometimes side lighting, with its interesting contrasts, helps characterise the features and shapes of the male face. Young subjects often turn out better if drawn in spontaneous poses and expressions, while mature men are better suited to more composed and 'dignified' poses. Make sure that the model does not cross his arms in front of him or appear authoritarian and off-putting.

Self portrait (See page 44). Almost all artists have drawn, painted or sculpted their own portrait. If you do the same, you will find that it will help to considerably improve your portraiture skills. Position yourself in front of a mirror and study your reflected face experimenting with different types of lighting and poses and then choose the pose you find most comfortable and which shows the 'real you'. Follow the procedure I outline on page 32.

The elderly Elderly people, both men and women, are very interesting to draw because their faces, marked by the passage of time and characterised by their everyday expressions, tell a 'story' of life and experiences. For this reason it is easier to capture their physiognomic traits, than it is with young people, and achieve a true likeness. Choose poses suited to the wisdom and tolerance which should come with old age.

Avoid strong and direct light on the model. Even if effective, it can easily lead you to draw an unflattering portrait and can unpleasantly emphasize any irregularities of the skin. Note the 'anatomic' changes in elderly people's heads: wrinkles on the forehead, near the eyes and the mouth, and on the neck; whitening and thinning of the hair; hollowing of the eyeballs; lengthening of the ears, and so on.

THE SIZE OF THE DRAWING

In a portrait drawing the dimensions of the face should not be more than two-thirds of the real face to avoid altering the proportions. You should use a maximum size of 40 x 50cm (16 x 20in) for the drawing surface, when portraying just the head, and 50 x 70cm (20 x 27½in) for the whole figure. Make sure the face is not at the very centre of the drawing surface, but slightly higher and to one side (see page 24).

CHOOSING THE POSE

(See page 25). Usually, a portrait reproduces head and shoulders, i.e. the torso, but it could also include the arms, the hands or the whole body.

If you draw from life make sure the model sits in a natural and comfortable position, and that their face is more or less level with yours. The pose should be relaxed, but clearly convey the subject's character to enable you to capture the psychological, as well as the physical likeness. It's better to choose a pose which highlights the somatic characteristics of the subject, so place yourself at a distance of about 2m (6½ ft) to offset any foreshortening effects. As a rule, the three-quarter view is considered the most effective but profile or full face can also be interesting.

LIGHTING

(See page 30). Lighting should be gently diffused, and from just one source (window or lamp) positioned slightly higher than the subject and from the side. This will highlight facial features, but will do so gently, preventing the formation of ugly shadows under the nose, the lips and around the eyes. Avoid intense artificial light (for instance, from a spotlight) as well as direct sunlight which create such effects; they emphasize the tiniest creases in the skin and affect the subtlety of the modelling. In addition, they force the model to contract their facial muscles giving a frozen, unnatural expression.

CLOTHING

Clothes have considerable importance, particularly in a full-figure portrait, both for their compositional and aesthetic function, and because they not only supply information about the personality, social status, and emotional state of the subject, but also about the era and background. Therefore, leave your model free to choose what to wear and limit yourself to suggesting some items of clothing which, because of their shape and arrangement, can make the composition of the drawing more effective. Arrange the folds and notice how different they look depending on whether the fabric is light and soft (lots of little folds) or heavy and stiff (a few thick folds), although in both cases they radiate from the top of the 'centres of tension': shoulders, elbows, knees, etc. Draw the folds which, due to their direction and size, are the most significant and ignore the minor ones which could create confusion. In some circumstances, partial nudity (shoulders, breast or back, for instance) can enhance the portrait of female subjects with a particularly vivid and strong personality (see page 56).

HAIR

Hair (as a whole and in relation to colour, quantity, and quality of the cut) is essential to characterise a face. The artist can use its look to improve the composition of a portrait, by weakening or enhancing, by contrast, the model's physiognomic traits.

If you draw female subjects (whose hair is usually thick) go for simple, tidy, well-cut hair. Hair should be treated as a whole. Capture its colour and overall form and try to pick out the most significant locks. Of these, assess areas of shadow and light, and lines of separation and disregard small, insignificant highlights and single hairs - you will need just a few fine and sharp strokes to suggest them. Use a fairly soft pencil to draw thick confident strokes, in various directions, to achieve unusual 'weave-like' effects. Draw the hairline very carefully, making it irregular and soft and pay particular attention to the forehead and the temples.

THE BACKGROUND

A portrait requires a background which is plain and unobtrusive, in shades which don't clash with one another or weaken the subject's appearance. Before you start, decide whether a light background (the white of the paper, for instance) or a dark one is suitable. In some cases the subject's surroundings (workplace, house, garden, etc.) can act as background - treat it as if it were a landscape or an interior - making sure, however, that it doesn't overshadow the face or the figure.

HOW TO GET A LIKENESS

As we know, portraying a human subject means perceiving and representing both the physical and the psychological aspect of the model. To achieve a physical likeness (see page 32), pay particular attention to the overall shape of the head (drawing 'from the general to the particular') and exactly evaluate your subject's proportions, both in the face as a whole and between its elements (eyes, nose, mouth, etc.). To achieve a psychological likeness, converse with your model, try to understand their character, preferences, habits, and observe the environment where they live and work. Of course this is not always possible, but it can be very useful to give you an idea of the most suitable pose and which aspects of their character are worth highlighting or bringing to the fore.

TECHNICAL AIDS

Photography

Photography is useful to record spontaneous and fleeting images of the subject, to have a point of reference when it isn't possible to organise sittings, and to portray children.

Take photographs yourself (modern automatic cameras make this easy even if you are not an expert) as they should be a term of reference rather than images to copy passively. Allow for perspective distortion and, to avoid or reduce it, do not get too close to the subject. Use, if possible, natural lighting and avoid flash which is unsuitable for portraiture.

Sketches

Get used to doing plenty of little sketches to study the main lines of the face and figure of the subject you are drawing (especially if you are working from life). Gauge the best composition, the most suitable lighting, the most convenient dimensions, etc. by walking around your subject. These sketches, even if done quickly, require careful observation, almost a commitment to 'explore' the aesthetic possibilities offered by the model. It may be from them that a successful portrait depends. After you have become more experienced at drawing the face, you may want to start painting it; then you will find it useful to do a preliminary study, more complex than the sketches, to help you sort out any aesthetic problems and to note down all the information which you will need for the definitive work.

Enlarging

Whether you are planning an accurate drawing, or you are attempting to paint a colour portrait, you will need to trace on the definitive support (paper, canvas, card, etc.) the outline which will serve as a base for the work. To this effect, you can, at least to start with, take advantage of a number of devices to effortlessly enlarge a sketch or even a photograph to the desired dimensions. You can use an ordinary slide projector to magnify the image on to the support and trace the face or figure's main contours.

Alternatively, you can use an episcope: an optical tool which allows you to enlarge and project images from opaque supports (photographic prints, sketches or reduced photocopies of drawings and paintings, etc.). These are practical devices, almost 'tricks' which may even harm one's artistic growth if one becomes dependent on them. More appropriate, therefore, is the 'grid of squares' method, which is well known even at school level. Draw a grid of squares on the image to be enlarged (whether a drawing or photograph) and then transfer that same grid, with the same number of squares, enlarged, on to the larger surface. You can then easily transfer strokes within individual squares keeping them in proportion.

The working environment

If you have your own studio, or at least, a room in the place where you live and you are determined to devote yourself body and soul to portraiture, you will find some furnishing accessories rather useful. For example: a chair, an armchair or a small couch for the subject to be comfortable and relaxed on while posing; a lamp which will allow you to adjust the intensity of the lighting so that the model is properly lit; a radio or a small TV to make posing less of a burden for your sitter (and for you). Remember to allow for frequent breaks and to take advantage of these intervals to study your subject in different expressions and poses.

You can place your support on an easel or the tilting surface of a special table but, more often, it will be sufficient to place it on a stiff board (made of wood, cardboard or MDF), 50 x 60cm (20 x 23½ in), and which you can rest on your knees. This simple equipment, together with your favourite drawing media, will come in useful when working outdoors, in public places or (and I hope this will happen soon) when going to the house of someone who has commissioned you to do a portrait.

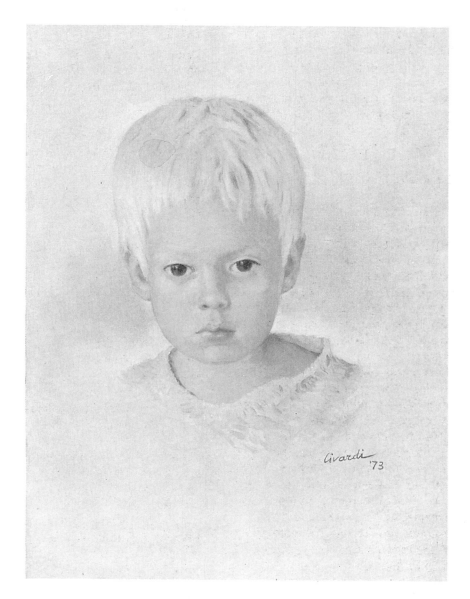

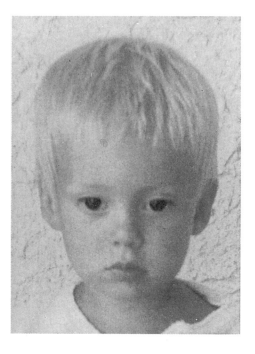

Portrait study, oil on canvas, 30 x 40cm (12 x 16in).
This portrait was not drawn from life but from the photograph on the left. Look carefully at the two images to find out to what extent the photographic information has been adhered to, highlighted or disregarded in the drawing.

DRAWING THE HEAD

PROPORTIONS

When drawing the head it is necessary to make sure that the proportions, i.e. the relative dimensions between its various constituent elements (eyes, ears, nose, mouth - which we will examine one by one later on) are indicated correctly and precisely. Of course, heads vary greatly in size and in the combination of characteristics, but they can all be reduced to a proportional diagram which helps to simplify the shapes, to recognise their peculiar three-dimensional aspect, and also to position details correctly in relation to one another. When drawing a portrait pay close attention to the overall structure of the head and evaluate its main characteristics as it is mainly from these that a good likeness depends. Details alone, even if minutely reproduced, almost invariably result in a vague and unsatisfactory portrait, when placed in a general context which lacks accuracy.

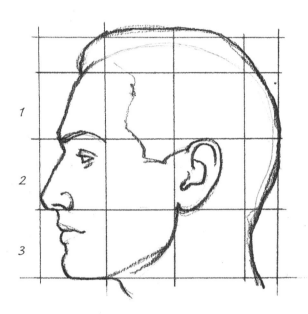

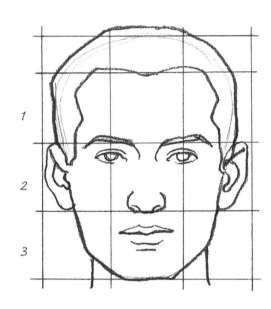

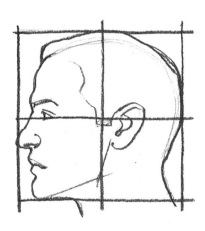

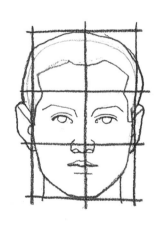

The diagrams shown here, if studied carefully, will provide you with the simple and essential elements of reference and proportion of a 'typical' head seen in frontal and lateral projections. Compare them with those of your model and assess whether they correspond or differ. The height of the face can be divided into three portions of equal size, which correspond to the height of the forehead (up to the hairline), that of the nose, and that of the lower part of the face.

In addition, note that if you join the three points located above the bridge of the nose, on the chin and at the corner of the jaw (near the earlobe), you have an equilateral triangle. The same figure is obtained if you join together the outer corners of the eyes and the base of the lower lip. The width of the eye viewed from the front is a useful reference for measuring the distance between the eyes (according to an old academic maxim 'between eye and eye there is an eye') and the width of the base of the nose level with the nostrils. Notice how, viewed from the top, the head's shape is an oval, broader at the back.

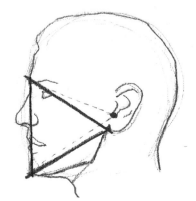

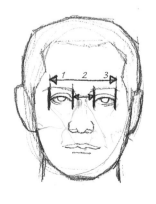

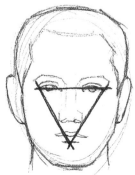

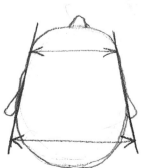

PERSPECTIVE

Perspective is a graphic method which helps to represent spatial depth on a flat surface. Therefore, to be represented correctly, the head too needs to be drawn (like any other object) bearing in mind the rules of perspective.

 The diagrams shown below will be enough, I think, to remind you of some of the basic principles, such as the horizon line, the viewpoint and the vanishing points. If you imagine the head within a cube whose edges touch its most protruding points, you will find it easy to 'put in perspective', fairly correctly the details of the face. You can then conduct a more accurate study considering the 'geometrised' head represented by two ovoids and a cylinder (see diagrams on page 12).

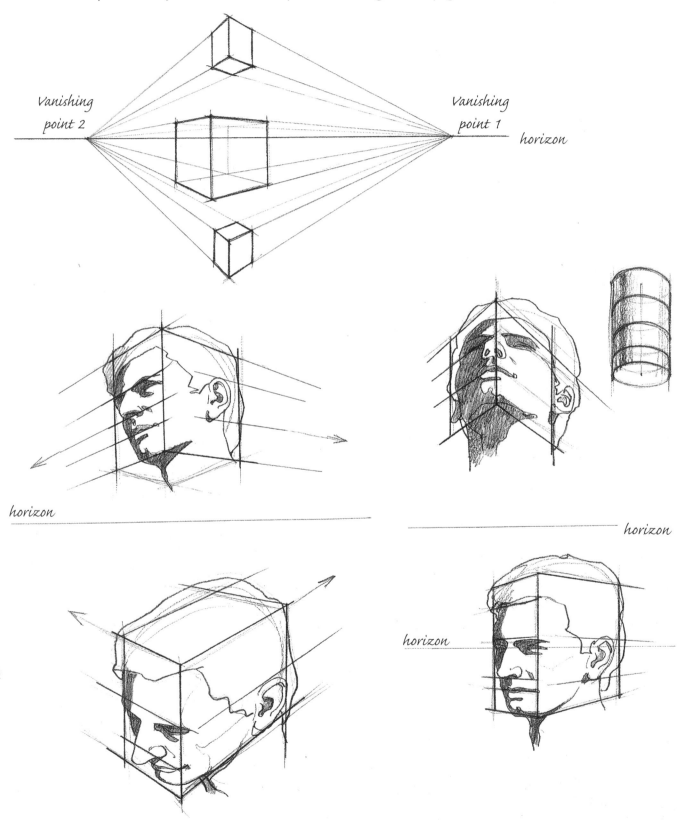

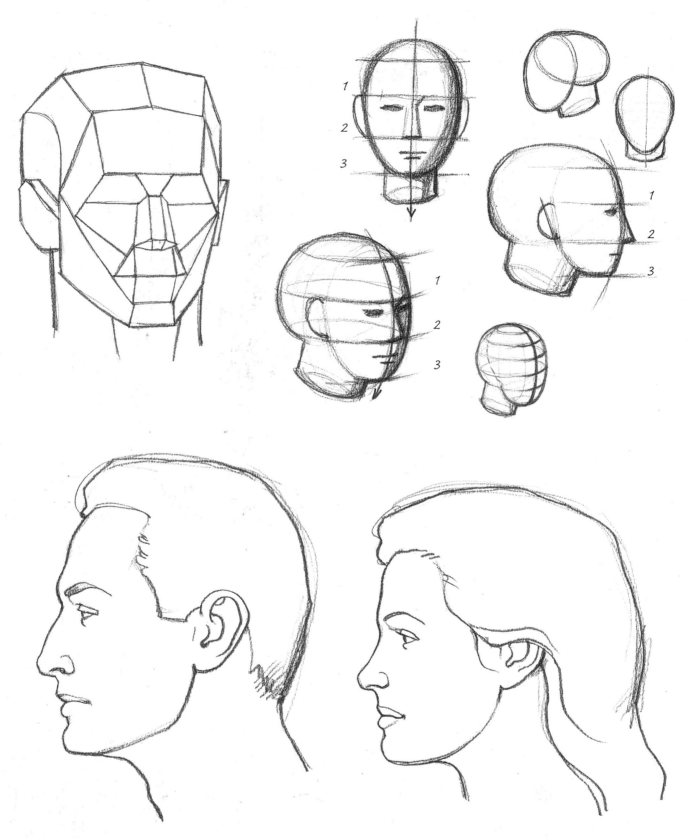

CONSTRUCTIVE SKETCHES

The head can be compared to the geometric shape of an ovoid and this, at the beginning at least, makes drawing it simpler, as far as proportions, as well as light and shadows are concerned. Notice how the two ovoids which represent the face and the skull can be superimposed. However, the roughly round shape of the head can also be divided into flat areas. As a whole, these 'surface planes', are useful for concisely shaping areas of light and shadow. Try drawing surface planes on to photographs which show heads in a variety of positions, and learn to recognize diagrams similar to the ones above.

When you first start drawing the head, which is a very complex shape, you are likely to encounter great difficulties and won't know where to start from. A traditional and scholastic, but very useful, approach is the one mentioned on these pages and which is developed further in chapter 12 (see page 32). Bear in mind that in portraiture it is essential, first of all, to capture the overall individual characteristics of the model's head and then study the characteristics of the details and how they relate to one another.

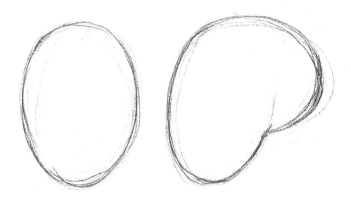

Stage 1

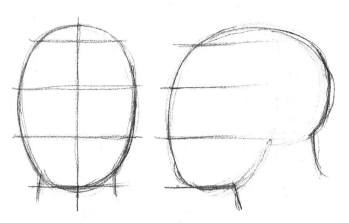

Stage 2

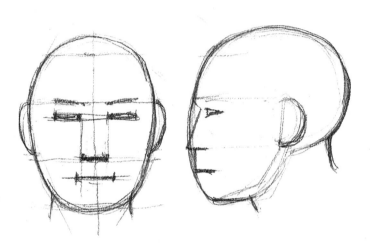

Stage 3

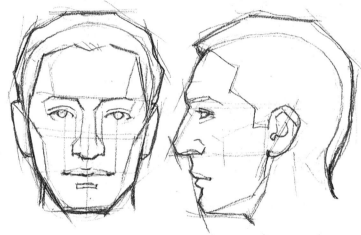

Stage 4

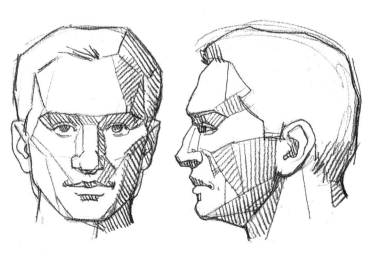

Stage 5

In these diagrams, limited to the front and side projections of a man's head, I have illustrated the various stages of construction.

Stage 1
Outline on the page the area you expect the head to occupy: draw a simple oval shape.

Stage 2
Indicate the proportions by way of four horizontal parallel lines more or less equidistant to suggest the three parts in which the face can be divided.

Stage 3
Carefully work out the position of the eyes, nose, mouth and ears by measuring their relative distances.

Stage 4
Thoroughly study how the elements of the head relate to one another, hinting at the 'planes', the hair, etc., coming close, little by little, to the natural shapes.

Stage 5
Continue to elaborate assessing also the light effects, that is, applying the 'chiaroscuro'.

ANATOMY

A basic knowledge of the anatomy of the head and adjoining areas (and, if possible, the hands, too) is useful to help fully comprehend the external shapes even if it is not, by itself, enough to guarantee the successful rendition of a drawing.

THE BONES

The shape of the skull determines by and large the external morphology of the head and can be divided into two parts: the brain case and the facial block, which comprises several bones tightly joined together to achieve a solid structure. The only mobile bone is the jaw.

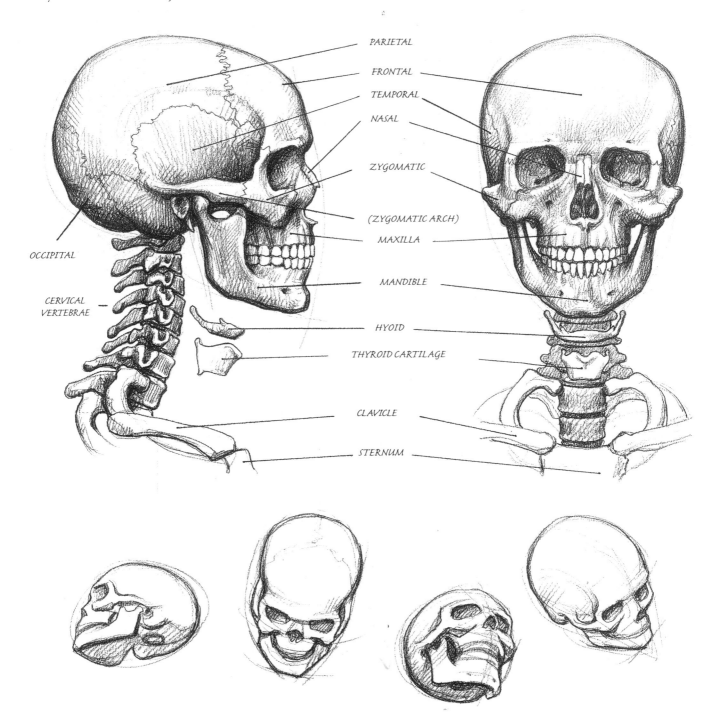

PARIETAL
FRONTAL
TEMPORAL
NASAL
ZYGOMATIC
(ZYGOMATIC ARCH)
MAXILLA
MANDIBLE
HYOID
THYROID CARTILAGE
CLAVICLE
STERNUM
OCCIPITAL
CERVICAL VERTEBRAE

If you get the opportunity to observe a real skull or to buy a plastic one, practise drawing its main outline. Render it from different visual angles, as I have shown in these quick sketches, and apply the principles of perspective and structural simplification.

THE MUSCLES

The muscles of the head are divided into two groups: the muscles of facial expression, responsible for physiognomic expressions; and the muscles of mastication, which move the jaw. They become stratified on the cranial bones whose external shape they follow pretty closely, as they are very thin. Also study the main neck muscles because, inevitably, they appear in nearly all portraits.

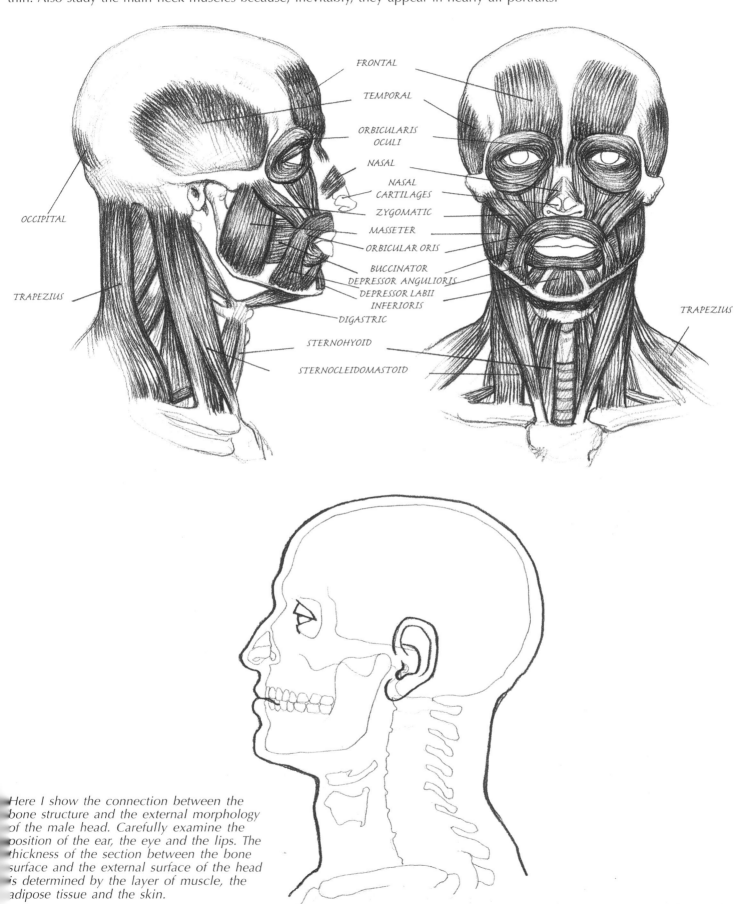

FRONTAL

TEMPORAL

ORBICULARIS OCULI

NASAL

NASAL CARTILAGES

ZYGOMATIC

MASSETER

ORBICULAR ORIS

BUCCINATOR

DEPRESSOR ANGULIORIS

DEPRESSOR LABII INFERIORIS

DIGASTRIC

STERNOHYOID

STERNOCLEIDOMASTOID

OCCIPITAL

TRAPEZIUS

TRAPEZIUS

Here I show the connection between the bone structure and the external morphology of the male head. Carefully examine the position of the ear, the eye and the lips. The thickness of the section between the bone surface and the external surface of the head is determined by the layer of muscle, the adipose tissue and the skin.

15

THE EYE

Once you have examined the overall structure of the head, you need to analyse carefully the individual details of the face, i.e. the nose, mouth, eyes and ears. It makes sense to be able to recognise the basic morphological, i.e. 'constructive' characteristics of each one, as by following them and precisely reproducing individual variations you will obtain a very good likeness.

 The eye is, perhaps, the most expressive element and it is therefore essential to draw it in the correct position and to the exact shape. Notice that the white section of the eyeball (the sclera) is not pure white but actually changes colour due to the effect of its own shadow and the one cast by the eyelid. Be careful to draw both eyeballs (and therefore both pupils) looking in the same direction as the expressiveness of the eyes depends on this.

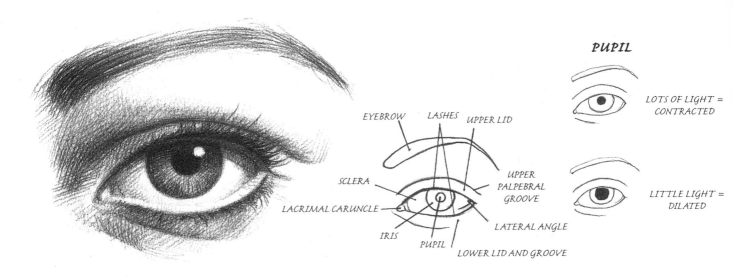

PUPIL

EYEBROW LASHES UPPER LID

SCLERA

UPPER PALPEBRAL GROOVE

LACRIMAL CARUNCLE

IRIS PUPIL LATERAL ANGLE

LOWER LID AND GROOVE

LOTS OF LIGHT = CONTRACTED

LITTLE LIGHT = DILATED

The diagrams below should be sufficient to show the spherical structure of the eye, how the eyelids rest on it and, finally, the stages to go through to draw it correctly.

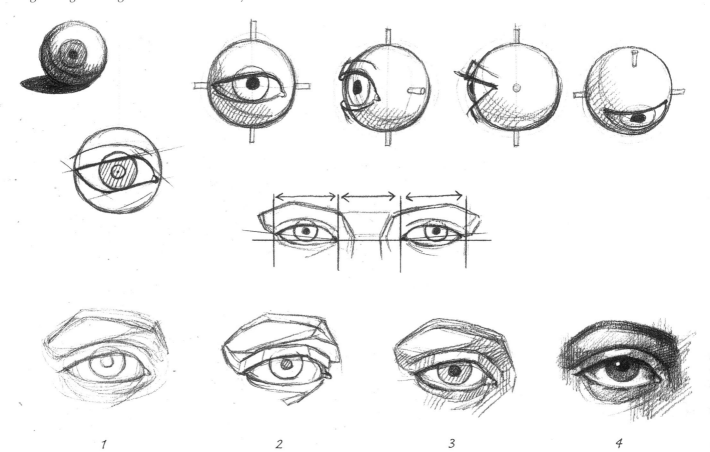

1 2 3 4

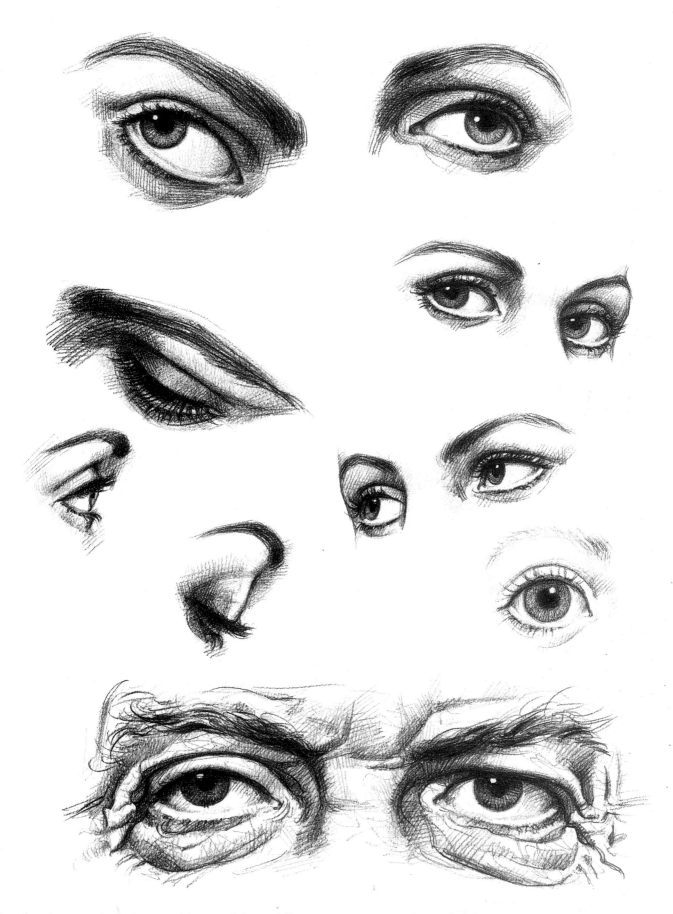

Practise drawing eyes in various positions and from different viewpoints, as shown by the examples on this page. The female eye usually has long and thick eyelashes, while eyebrows are well outlined and thin. The iris of a child looks very big compared to the eyelids.

Elderly people show several deep wrinkles radiating from the corners of the eyes, the lower eyelids become 'baggy', and eyebrows become irregularly thick and bushy.

THE EAR

The ear is supported mainly by thin cartilage arranged in circumvolutions. Although its morphological characteristics vary greatly, its overall shape recalls a seashell and is fairly similar in both sexes. Ears are often partly hidden by one's hair and their expressive character depends on their precise position on the sides of the head, as I have shown in the sketches below.

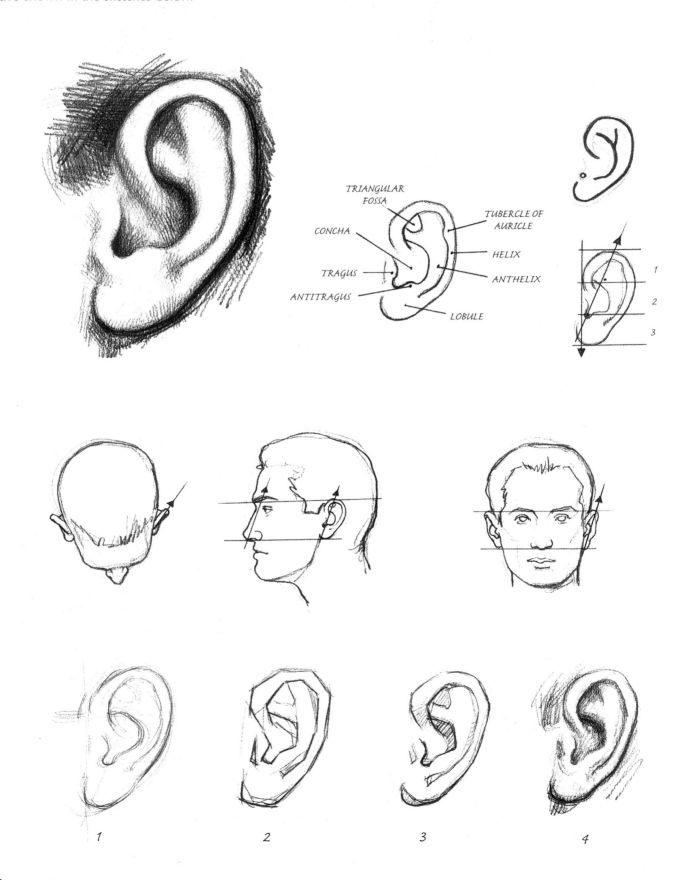

TRIANGULAR FOSSA

CONCHA

TRAGUS

ANTITRAGUS

TUBERCLE OF AURICLE

HELIX

ANTHELIX

LOBULE

1

2

3

1 2 3 4

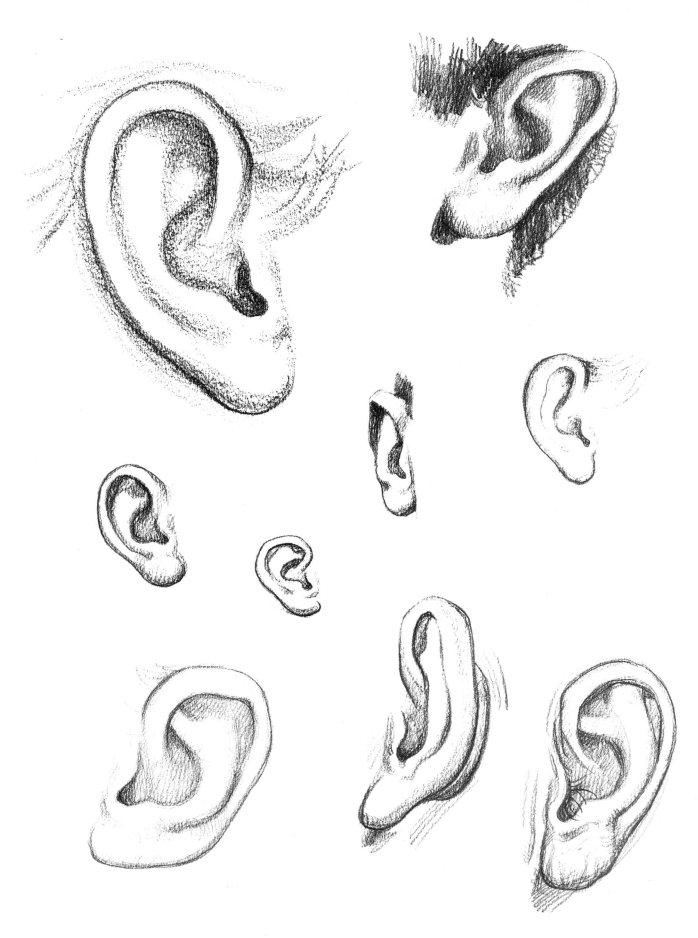

In an adult, the height of the ear corresponds, on average, to that of the nose; in a child it looks rather big in relation to the head; and in an elderly person it tends to lengthen because of the thinning and weakening of the cartilage tissue.

THE NOSE

The nose is rather difficult to represent as it sticks out of the face and therefore its appearance varies depending on the viewpoint. Its pyramid-like shape is partly due to two small, close together bones and partly to cartilages, and this can be seen clearly on its dorsum. Observe the sketches shown on these two pages and practise drawing the nose in various positions, referring to photographs if it makes it easier to understand its structure. Notice that the dorsum moves away from the bridge to reach maximum projection at the tip and its sides slope towards the cheeks. The triangular base hosts the nostrils, oval-shaped and slightly converging towards the tip, and delimited by the alae of the nose. Try to work out the most important areas of light and shadow (the maximum amount of light is usually on the dorsum and the tip, while the most intense shadow is at the base, near the nostrils) and indicate just those, to avoid making the drawing too 'heavy'.

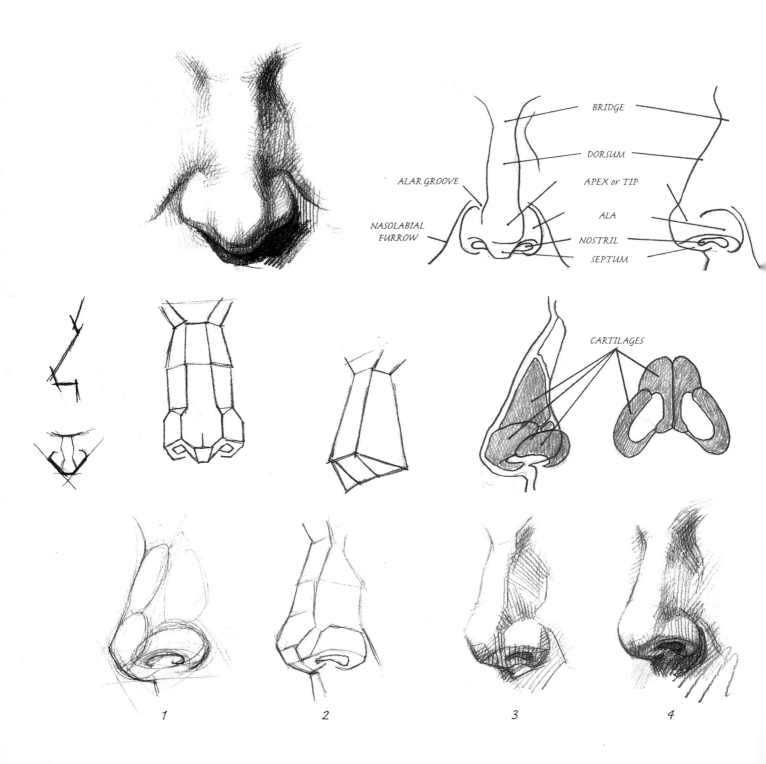

1 2 3 4

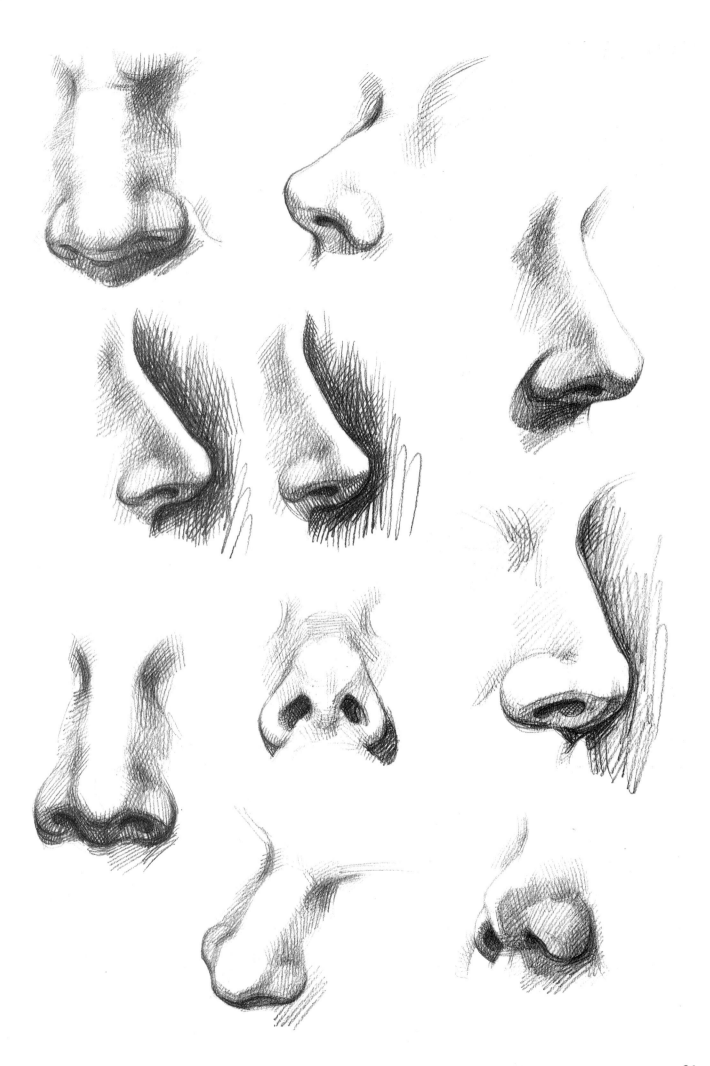

THE MOUTH

After the eyes the mouth is the second most expressive element of the face. The pinkish colour of the lips is due to the tissue they are made of, transitional between the mucous membrane (found inside the mouth) and the skin. When drawing the lips make sure that, above all, you carefully draw the line which separates them - ensure that it lies on the semi-cylindrical surface of the jaw bones and follows the rules of perspective I have already mentioned. The simple sketches shown below indicate some of the basic characteristics of labial morphology. Notice, for instance, that the upper lip is usually thinner and more protruding than the lower.

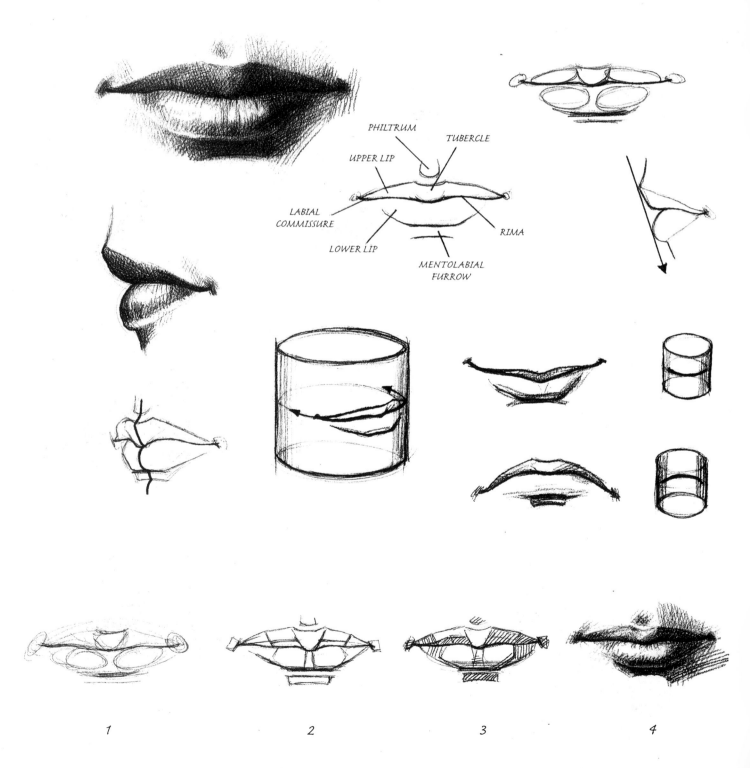

PHILTRUM

TUBERCLE

UPPER LIP

LABIAL COMMISSURE

RIMA

LOWER LIP

MENTOLABIAL FURROW

1 2 3 4

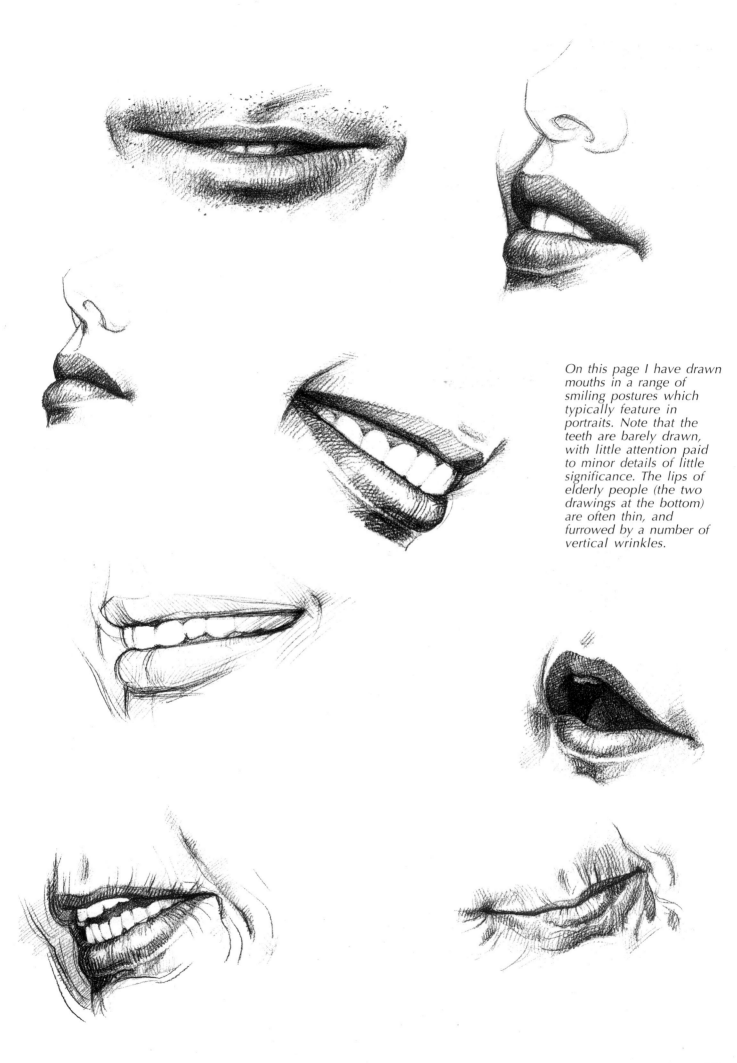

On this page I have drawn mouths in a range of smiling postures which typically feature in portraits. Note that the teeth are barely drawn, with little attention paid to minor details of little significance. The lips of elderly people (the two drawings at the bottom) are often thin, and furrowed by a number of vertical wrinkles.

PORTRAIT COMPOSITION

Composition involves arranging on the drawing surface the elements which make up the image we are set to represent. There are no firm rules (except, perhaps, the one concerning the 'golden section') but rather principles relating to our visual perception, i.e. unity, contrast and balance. Portrait composition dictates that we make some choices straight away: deciding whether to draw the full figure or just the head, and in this case, whether full-face, profile, three-quarter; deciding whether to place the model in some sort of setting or isolate them with a neutral 'background'; deciding the size of the drawing and whether it should be portrait- or landscape-style; and so on. You need to get used to doing lots of little sketches to evaluate these problems, as I suggest in the following pages. In the meantime look carefully at the sketches below, which use 'tricks of the trade' to direct you when you start, but don't allow yourself to be tied down by traditional and stereotyped formulas - do experiment with original and unusual compositions.

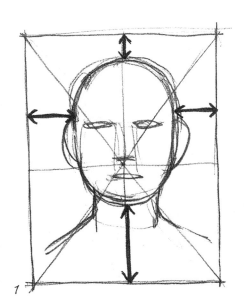

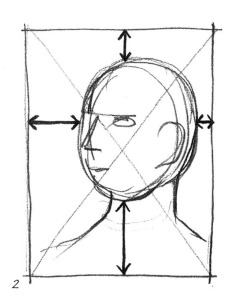

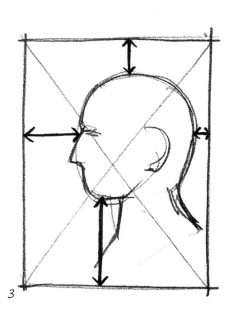

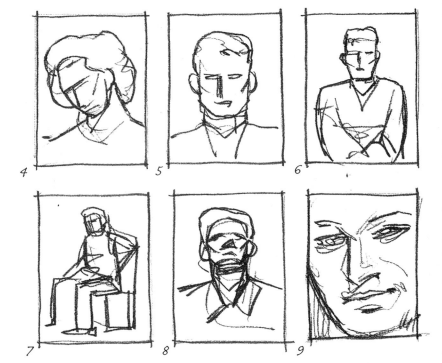

1 In a full face portrait you should not place the head right at the geometric centre of the page, but slightly higher, leaving more or less the same amount of space at the sides. Make sure, however, that the top of the head does not get too close to the edge of the page.

2 In a three-quarter portrait it's better to leave more room between the front of the face and the edge of the page, rather than at the back.

3 A profile portrait looks better if you leave lots of space in front of the face. Avoid, if possible, 'cutting' the head's back profile or making it fit with the edge of the page.

4 A bowed head can express a depressed mood.

5-6-7 A full-face portrait showing the subject in the foreground can radiate strength and self-confidence.

8 An image viewed from below can make the face look fierce and the attitude authoritarian. It is therefore not recommended for a portrait.

9 An unusual and evocative effect can be achieved by having the face take up the whole page.

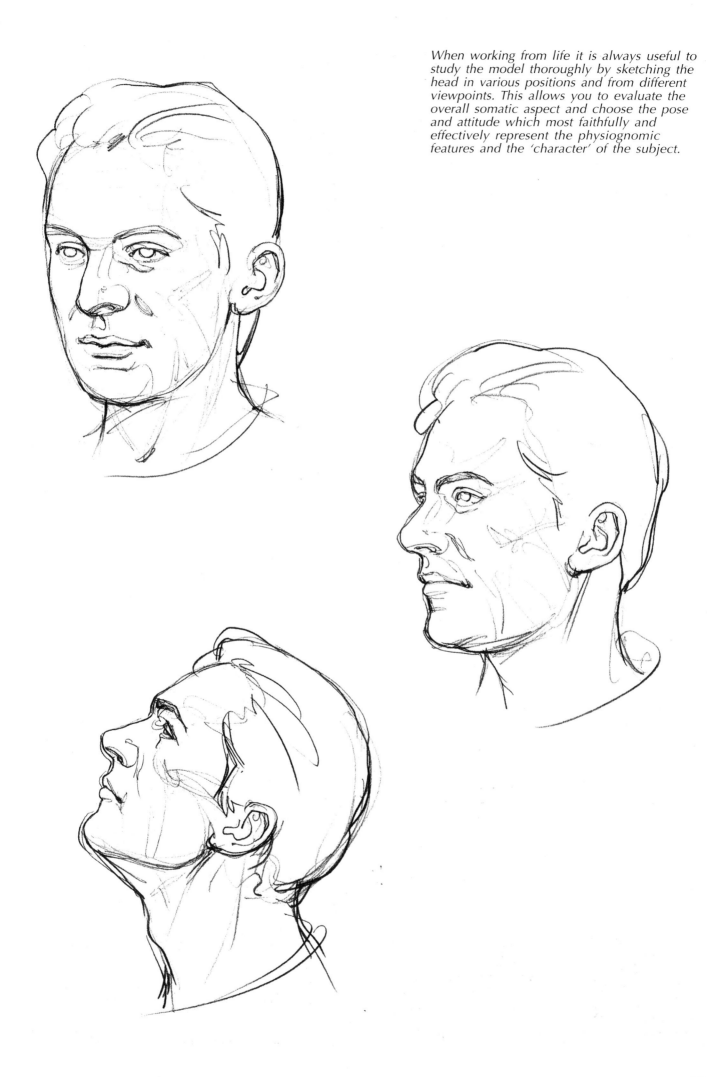

When working from life it is always useful to study the model thoroughly by sketching the head in various positions and from different viewpoints. This allows you to evaluate the overall somatic aspect and choose the pose and attitude which most faithfully and effectively represent the physiognomic features and the 'character' of the subject.

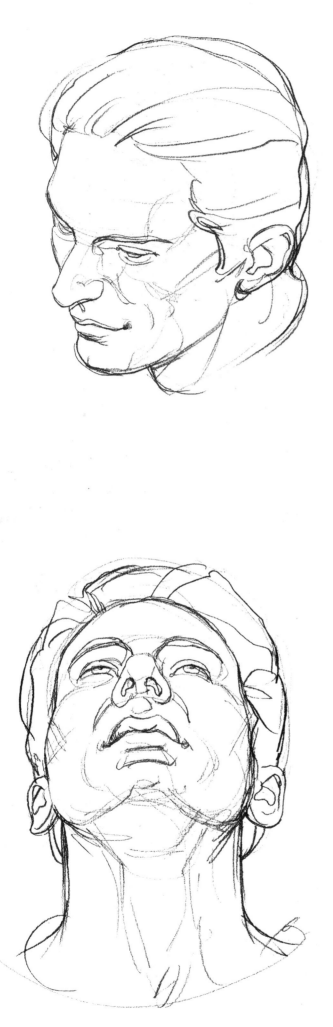

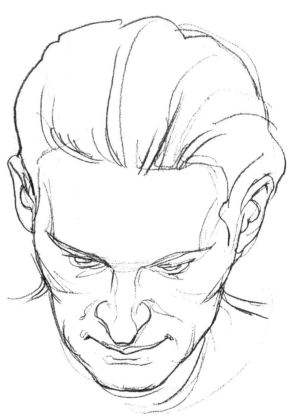

To work in a more relaxed way you can, to start with, use photographs but drawing from life is definitely more effective. In addition, it enables you to explore new compositional routes, 'going around' the model to catch every little expressive nuance and to master the overall shape, which is so important to achieving a likeness. Render these studies by way of simple, 'clean' strokes, aiming for the overall structure of the head rather than chiaroscuro effects.

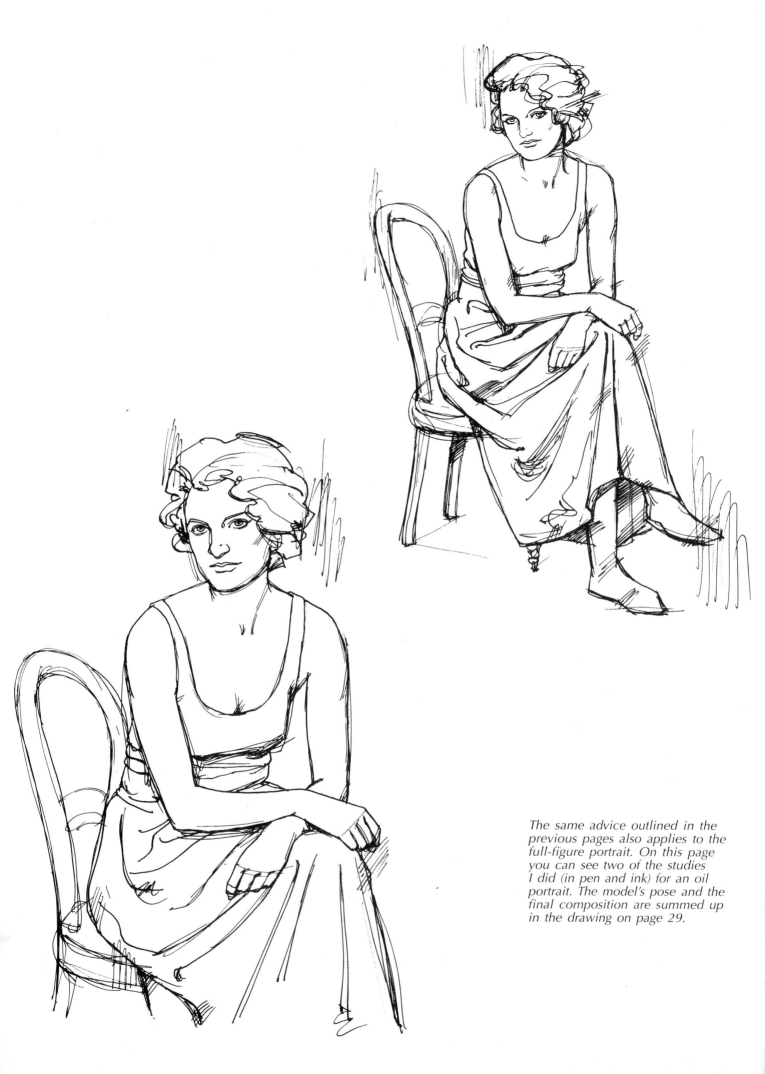

The same advice outlined in the previous pages also applies to the full-figure portrait. On this page you can see two of the studies I did (in pen and ink) for an oil portrait. The model's pose and the final composition are summed up in the drawing on page 29.

In full-figure portraiture the hands, as well as the face, have great importance and you need to find a pose which is expressive, yet conveys the whole. It is this latter aspect that I have tried to explore with the drawings shown on these pages.

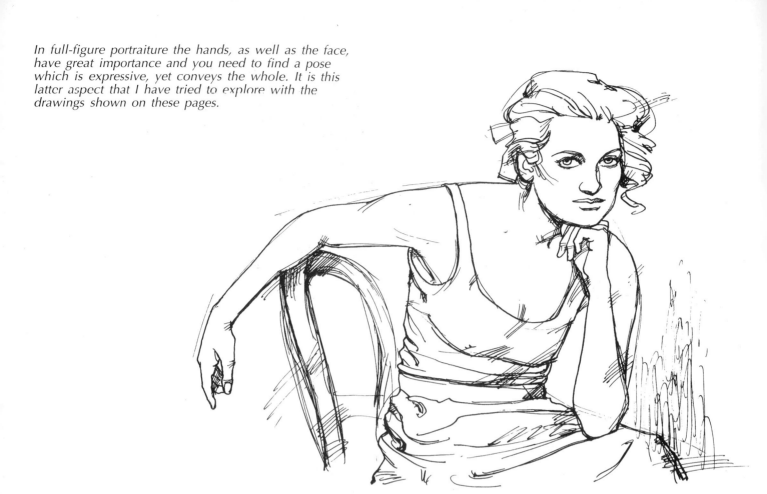

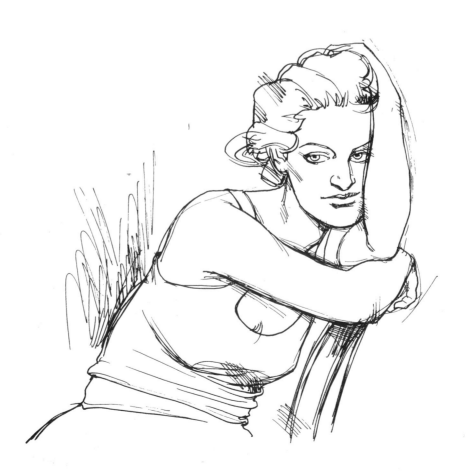

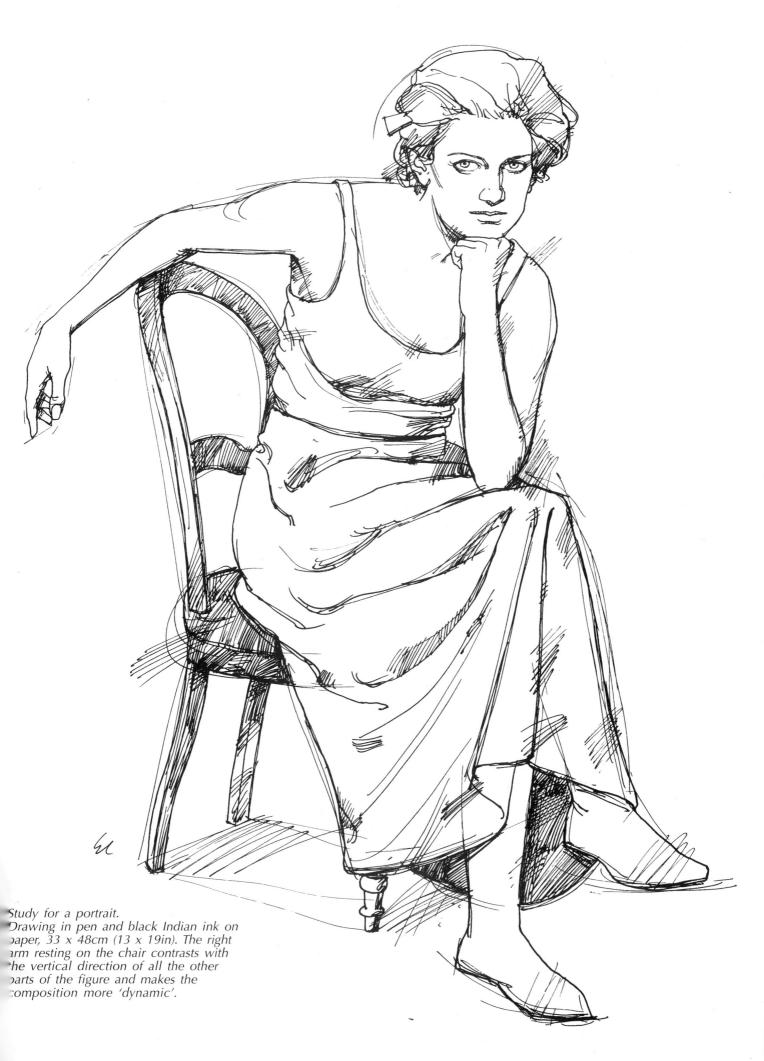

Study for a portrait.
Drawing in pen and black Indian ink on paper, 33 x 48cm (13 x 19in). The right arm resting on the chair contrasts with the vertical direction of all the other parts of the figure and makes the composition more 'dynamic'.

LIGHTING

When drawing a portrait it is very important to consider the direction, quality and intensity of the light falling on the model as it is thanks to light and shadows that we get a sense of the shape and the plastic form of the face. Usually when drawing a portrait artificial light, which is easy to adjust and constant, is preferable to sunlight, which varies highly in intensity and direction. Good lighting must highlight as best as possible the physiognomic characteristics of the subject. Therefore avoid using a light source which is too intense and close. It is better to use slightly diffused lighting, which doesn't create dark shadows, especially under the nose, the lips and the eyes.

The photographic examples on these pages are of a sculpture I moulded and show situations which are slightly unusual or extreme, but are useful to highlight the effects, both positive and negative, of different lighting on the face. The most suitable lighting for a portrait has the source slightly higher than the subject and midway between the front and the side. To make the light more diffused you can place a finely frosted glass in front of the source or use one of the well known photographic devices.

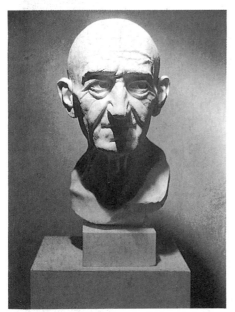

Top lighting

Is very effective but you have to be careful not to create excessively dark shadows under the eyebrows, the nose, and the chin. The surface-grazing light can exaggerate the reliefs and depressions of the skin.

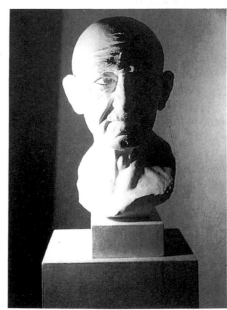

Side lighting

Is not suitable for portraiture as it divides the face into two contrasting halves: one lit, one in shadow. Sometimes it can be useful to convey strong relief.

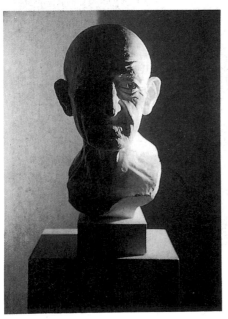

Side/back lighting

Should not be used for a portrait as it cancels most of the shape of the face. It can be used, however, when the head is in profile. Note, in this example, a device adopted in drawing - the dark part of the head is silhouetted against the light background and the light part against the dark background.

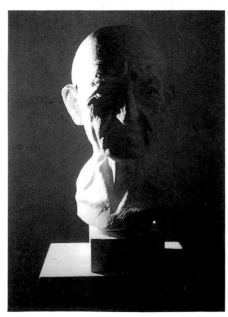

Almost back lighting

Also called 'effect lighting', is not used in portraiture as it makes the model's features hardly recognizable. The backlit image, however, can work for a portrait where the face is in profile.

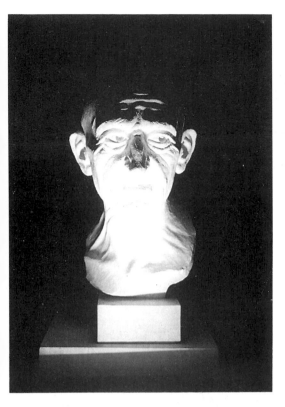

Lighting from below

Is very 'dramatic' and is hardly ever used in portraiture as it alters the likeness and distorts the characteristics of the face.

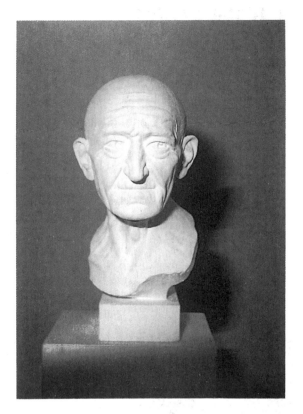

Front lighting

Is simple, but flattens the details of the face; it is very suitable, however, for 'linear' and decorative portraits.

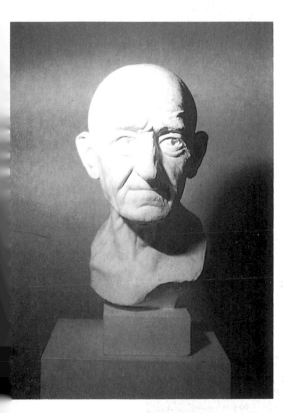

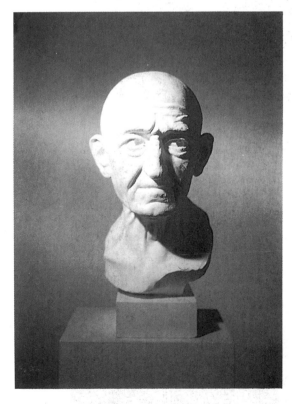

Angled lighting from above, midway between front and side: *is the type of lighting most widely used in portraiture as it properly highlights the physiognomic characteristics and effectively conveys the plasticity of the face. These two photographs vary slightly in the inclination and distance of the subject in relation to the light source.*

METHOD

In this chapter, up to page 37, I illustrate the stages one has to go through to draw a portrait. The method indicated is rather scholastic but useful to those new to portrait drawing. Once familiar with the elements which are essential to characterise a face, it will be easier and more spontaneous to move gradually from the first sketch to a more complex drawing and find your own, more immediate and personal, way forward. My advice is to do some of these exercises using live models and photographs, and to try to understand how each stage helps you tackle and solve a specific problem and how you get to draw a head correctly, at least from a formal point of view. Use sheets of white paper at least 30 x 40cm (12 x 16in) in size and pencils of various grades, as I have indicated.

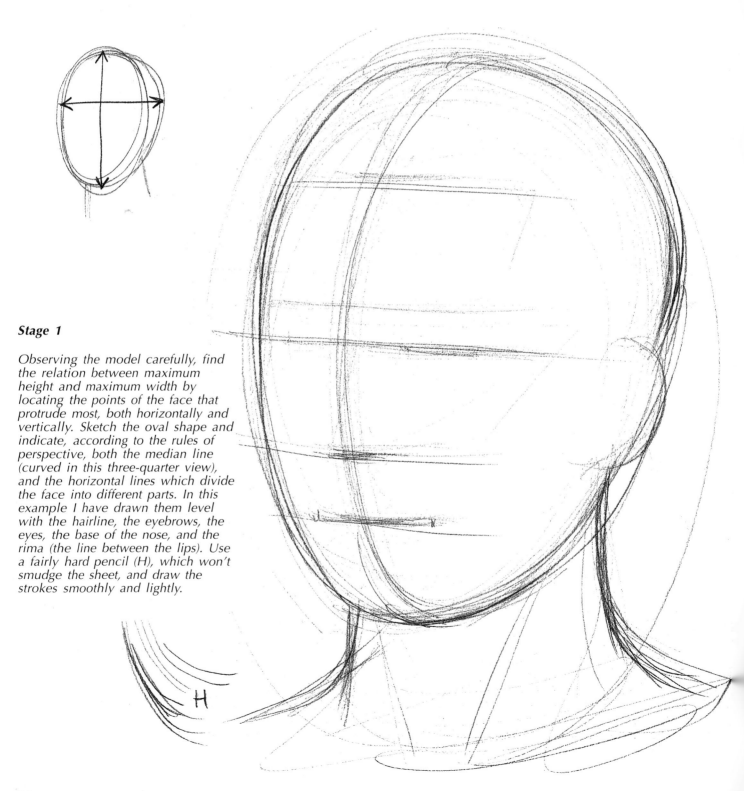

Stage 1

Observing the model carefully, find the relation between maximum height and maximum width by locating the points of the face that protrude most, both horizontally and vertically. Sketch the oval shape and indicate, according to the rules of perspective, both the median line (curved in this three-quarter view), and the horizontal lines which divide the face into different parts. In this example I have drawn them level with the hairline, the eyebrows, the eyes, the base of the nose, and the rima (the line between the lips). Use a fairly hard pencil (H), which won't smudge the sheet, and draw the strokes smoothly and lightly.

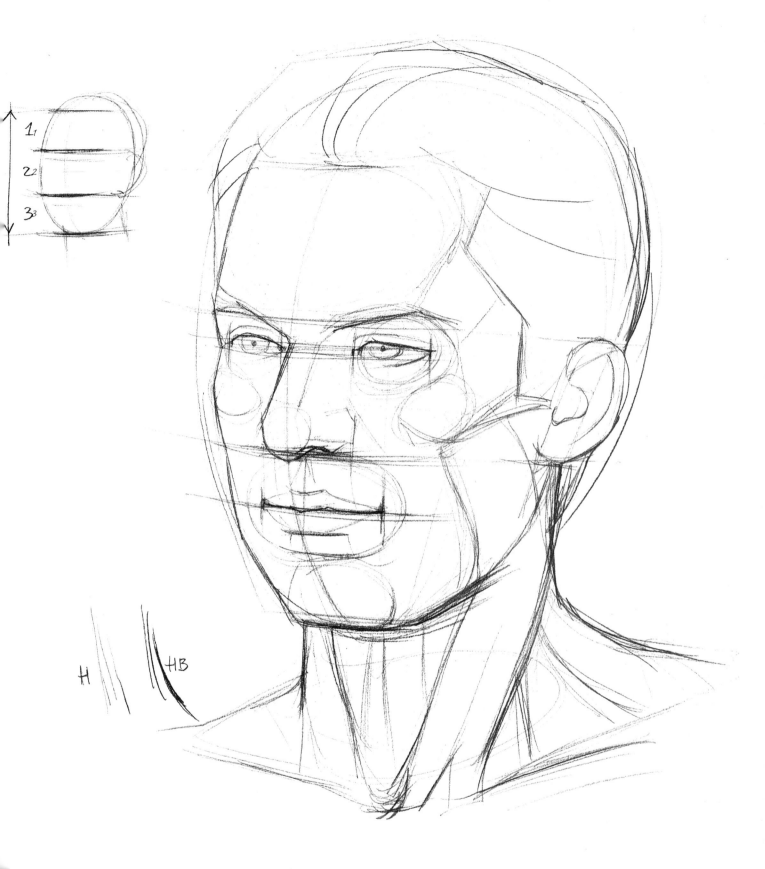

Stage 2

Continue to refine your sketch and carefully position the details of the face, i.e. the eyes, the nose, the mouth and the ears. Note that the subdivision of the face into three sections is just indicative. Try to find in each individual the specific relative proportions and stick to them to achieve a likeness. This stage is very important as it lays the ground for the subsequent development of the drawing. Also try to recognize and lightly sketch the main anatomic structures (the subcutaneous bones, the surface muscles, etc). Here, for example, I have indicated the protruding cheekbones and front bone, the position of the orbicularis oris, masseter and sternocleidomastoid muscles. Again, draw light strokes with an H pencil or, if you prefer an HB.

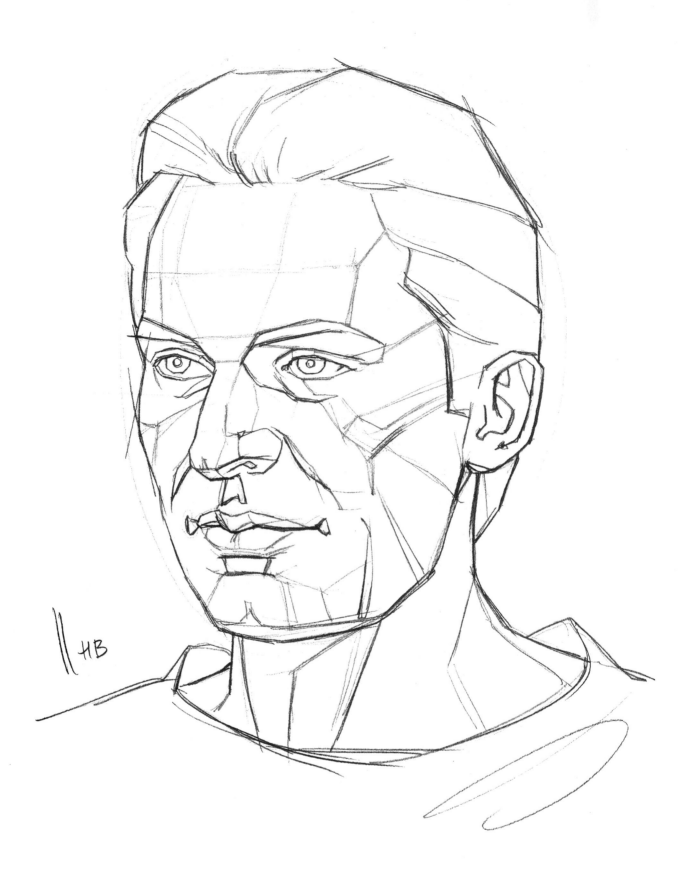

Stage 3

At this stage it's better to concentrate on recognizing the 'surface planes', i.e. those areas which are, in a barely noticeable way, distinguished by the different effect of the light. Concisely outline the areas (both lit and in shadow) which can, as a whole, help you give a feeling of solid volumetric construction to the drawing. Be careful not to overdo the straight strokes to avoid a 'hard', angular shape. However, a certain 'dryness' can help to simplify the tonal planes in view of the subsequent stages. Use a medium-grade pencil, such as HB.

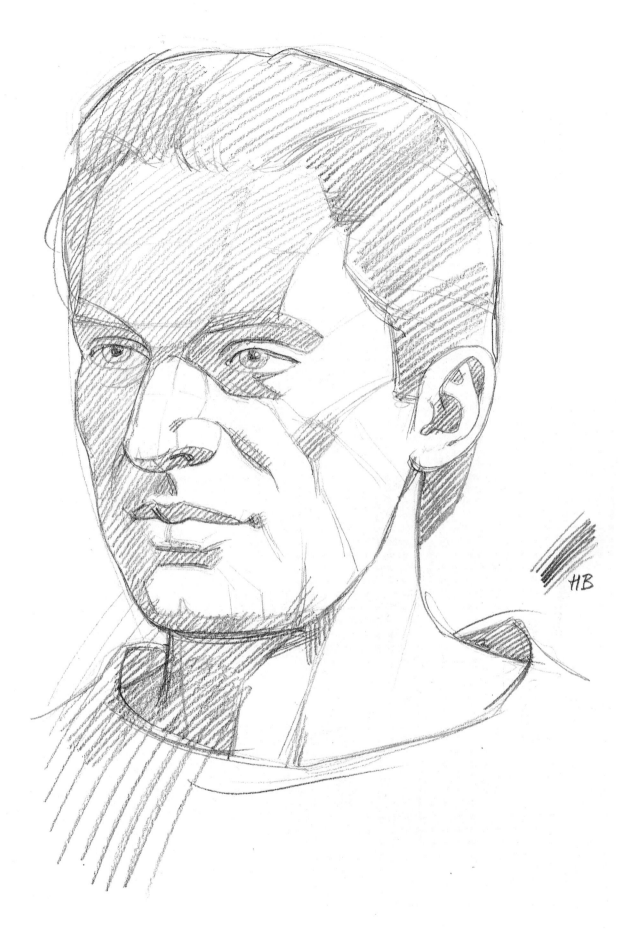

HB

Stage 4

At this stage we tackle the problem of shadows, already acknowledged in the previous stage, and we show the larger, more intense and important ones. You will notice that the shadows on a face vary greatly in intensity and are extremely complex. For the simplified view needed at this stage, half close your eyes until you perceive just two tones on the model - that of the lit section of the face and that of the areas in shadow. Again use a HB pencil lightly and rather evenly.

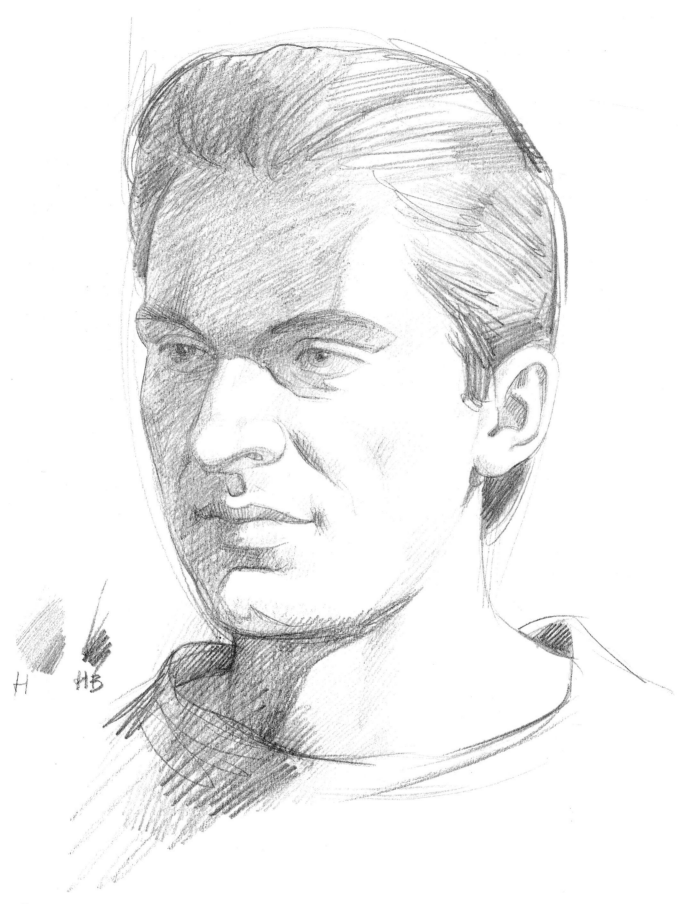

Stage 5

At this stage and, if necessary, in the next ones, proceed to fashion the surface shapes of the face, looking for the intermediate tones (which in the previous stage were left out and incorporated in the overall area of shadow). In addition, define the most significant details, for instance the eyes and the lips, enhancing or lightening the tonal values which define them. Again, use a HB pencil varying the intensity of the stroke by increasing or decreasing the pressure on the paper. H pencil can be used to indicate areas of very weak tone.

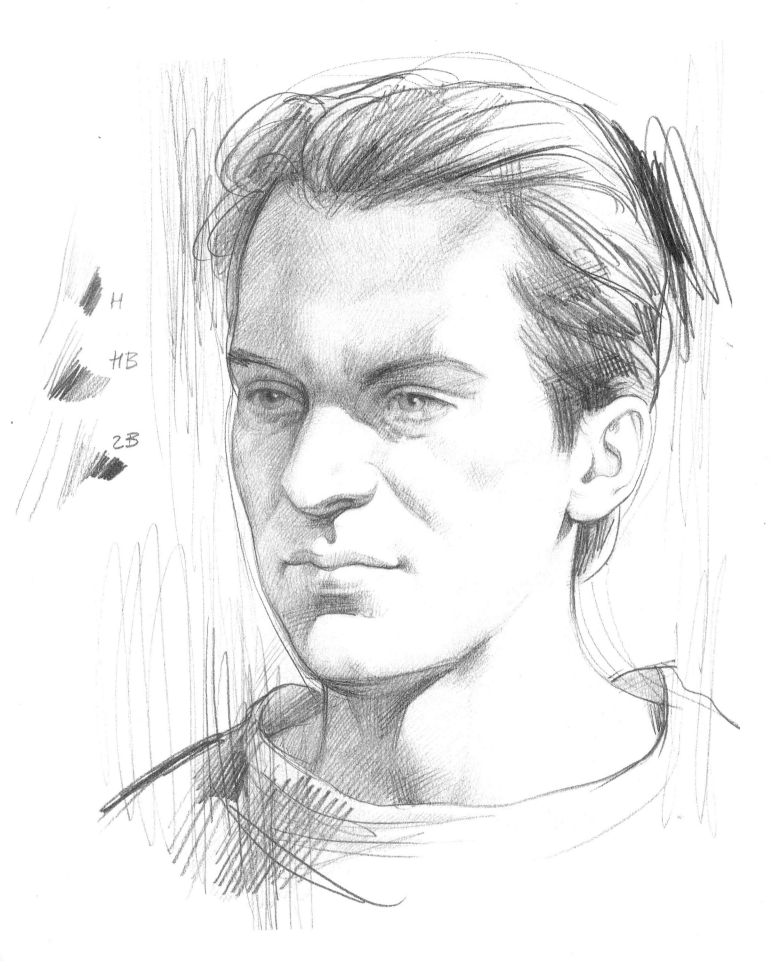

The drawing, now at an advanced stage, preserves traces of the previous stages. Do not erase them, rather 'soften them up', further perfecting the tones and blending them. It is impossible (and useless) to try to reproduce in a drawing all the tonal shades one finds in life. Therefore don't overdo the 'finishing touches' and the insignificant detail because a good drawing is always the result of careful selection and intelligent, sensitive simplification. Shadows can be intensified in places with a 2B pencil, which is rather soft.

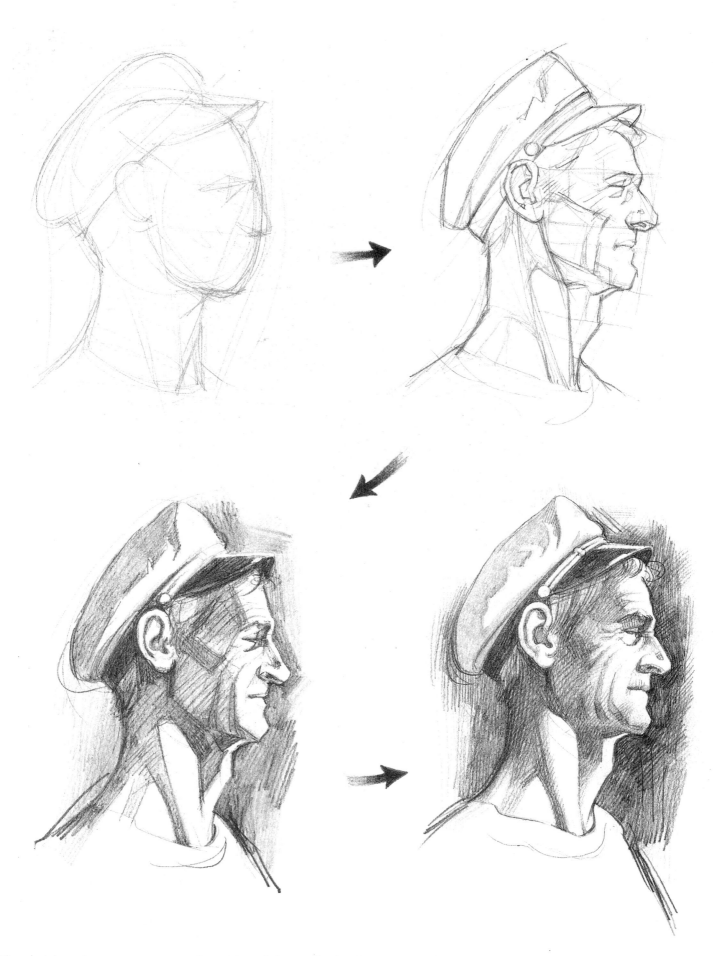

The sketches above are reconstructions (done 'afterwards' for the purpose of demonstration) of some of the stages which I follow as a rule, by now almost instinctively, when I draw a portrait.

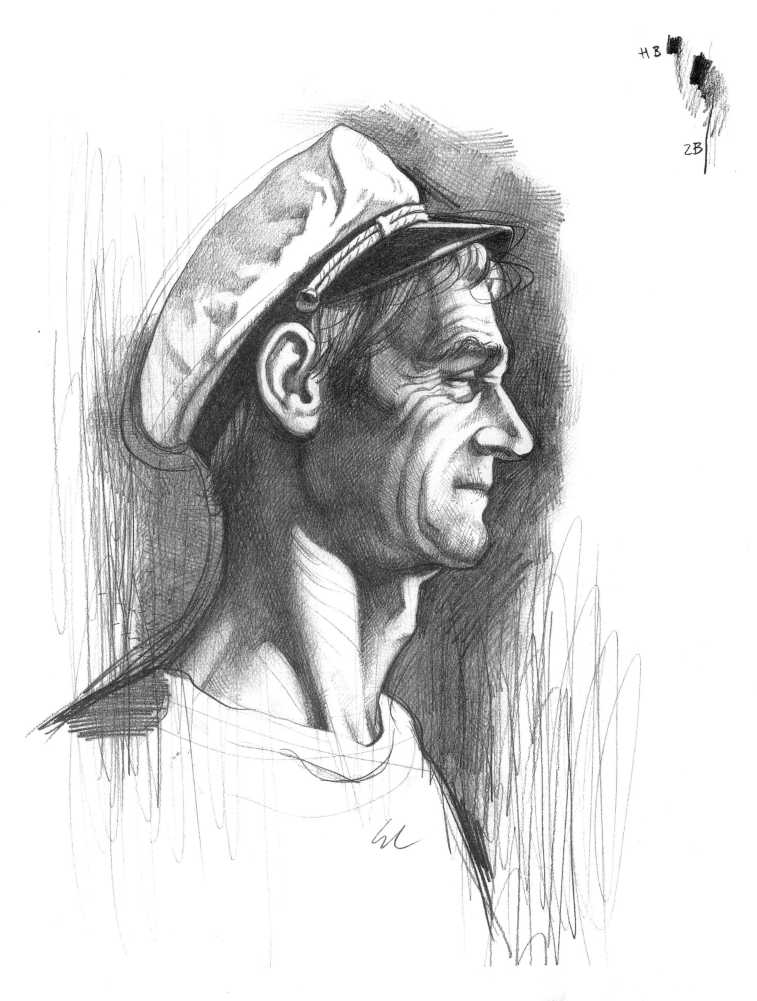

Portrait study: HB pencil (with some 2B added on) on medium-textured paper, 33 x 48cm (13 x 19in).

Charcoal is suitable for portraiture because it allows you to quickly and effectively tonally draw the face. The method is slightly different from that followed with a pencil: with a few light strokes outline the head, then fill and blend with your fingers or a wad of cotton wool (stage 1); exercising more pressure on the charcoal, darken the areas of the face which appear in shadow and blend again (stage 2); then gradually try to find the different tones of chiaroscuro, darkening some areas, lightening others more exposed to the light (stages 3 and 4). To erase or lighten tones use a kneadable putty eraser, gently pressing it and rubbing lightly. Do not grade the shading excessively or you will 'weaken' the drawing and give it a photographic, affected look. Rather, pay attention to the big masses and the main features of the face.

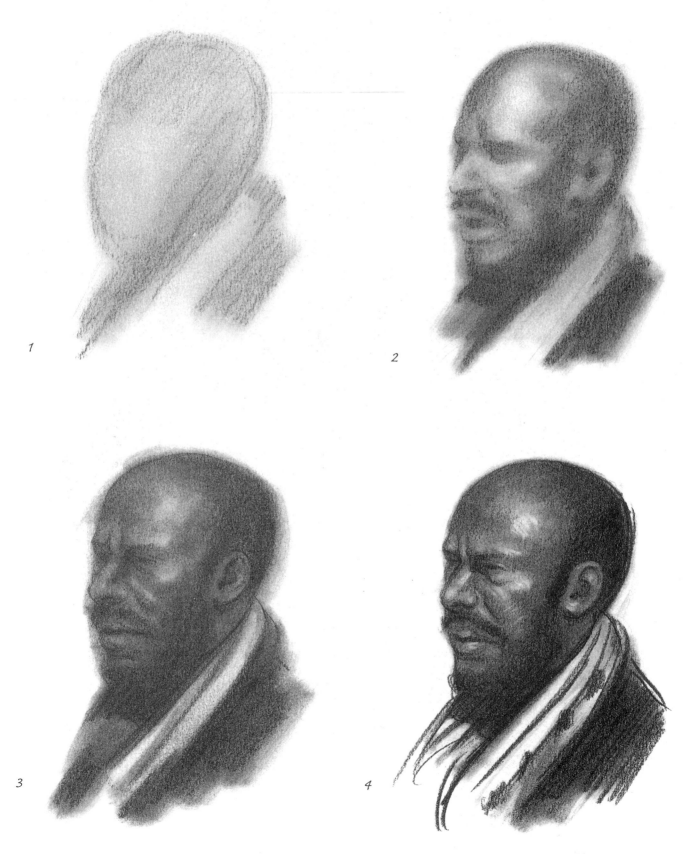

1

2

3

4

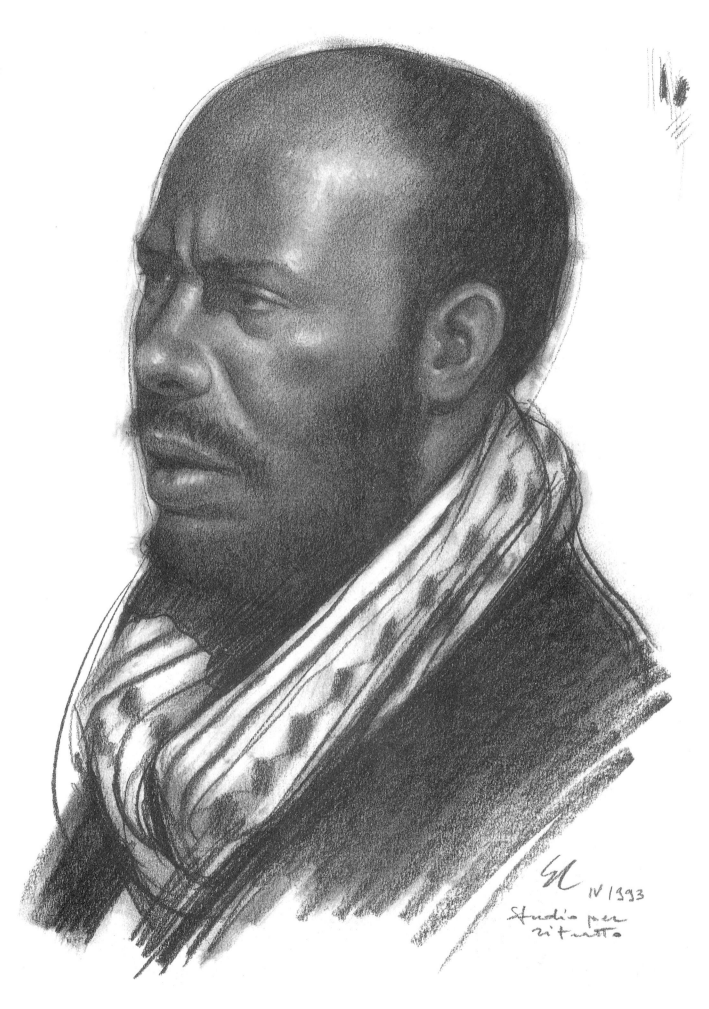

Portrait study: compressed sepia charcoal on medium-textured paper, 33 x 48cm (13 x 19in).

PORTRAIT STUDIES

In this section I have put together a series of portraits, some of which were done specially for this book, and others which were drawn previously. Almost all of them are studies for oil paintings or for more elaborate drawings and I chose them because the intermediate stages of implementation, more than the 'finished' works are the ones which show how to recognise and tackle the problems of composition, pose, anatomy and working technique.

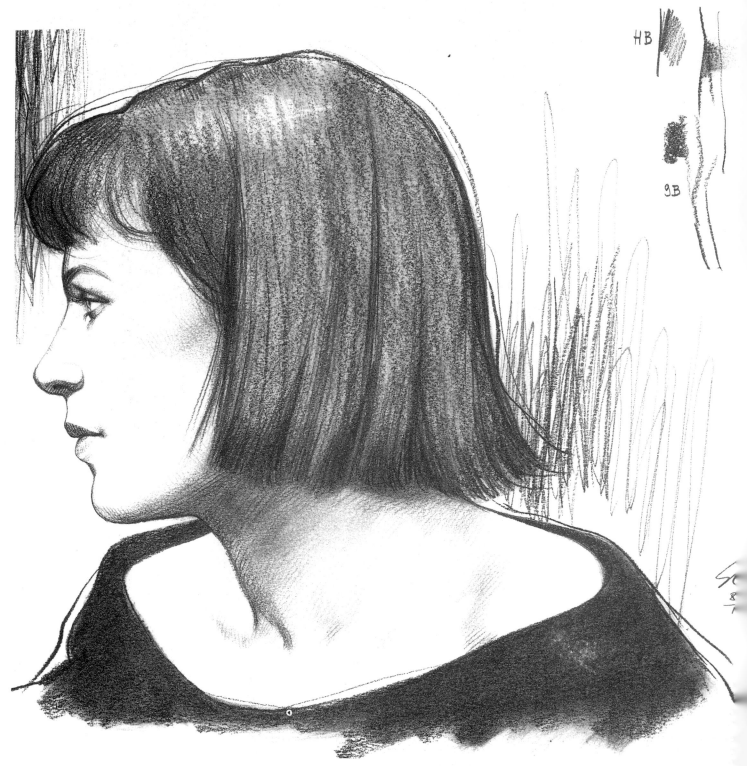

H, HB and 9B pencil on 30 x 40cm (12 x 16in) paper.
The portrait in profile works well with young subjects, especially female. The hair contrasts with the features and creates interesting 'graphic' effects of composition. For the hair I used HB pencil, lightly blended with a finger, and added darker accents with a 9B, drawing some 'flat' strokes, that is, using the side of the point.

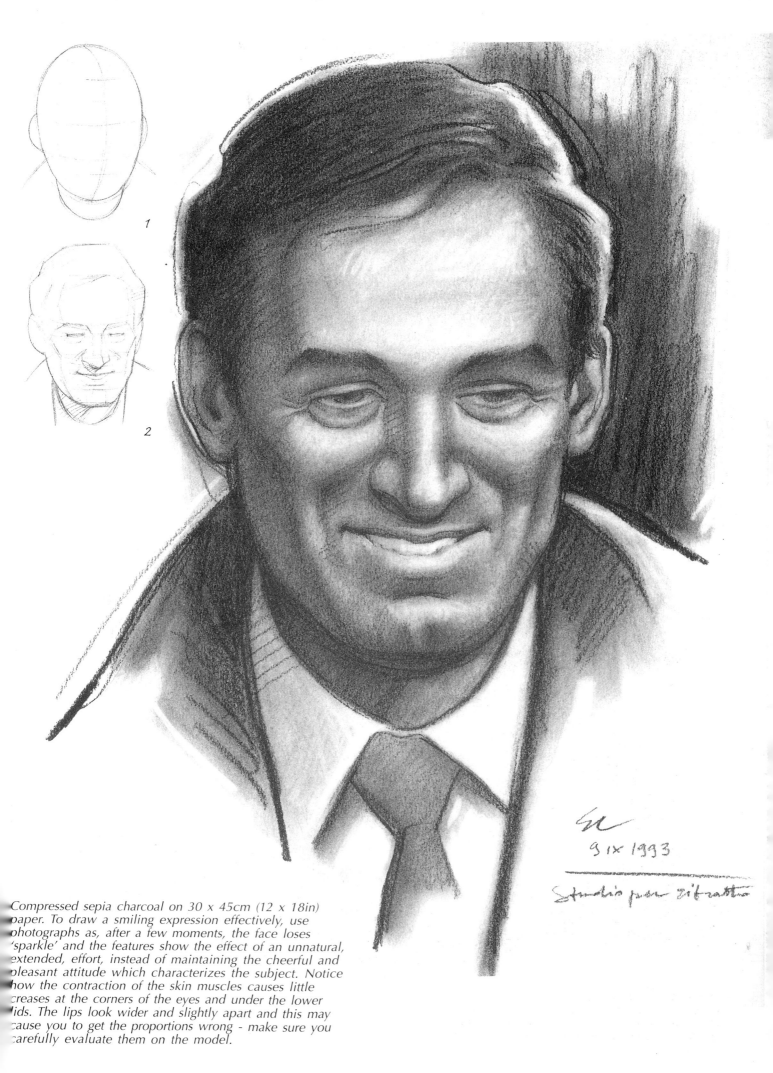

1

2

9 IX 1993

Studio per ritratto

Compressed sepia charcoal on 30 x 45cm (12 x 18in) paper. To draw a smiling expression effectively, use photographs as, after a few moments, the face loses 'sparkle' and the features show the effect of an unnatural, extended, effort, instead of maintaining the cheerful and pleasant attitude which characterizes the subject. Notice how the contraction of the skin muscles causes little creases at the corners of the eyes and under the lower lids. The lips look wider and slightly apart and this may cause you to get the proportions wrong - make sure you carefully evaluate them on the model.

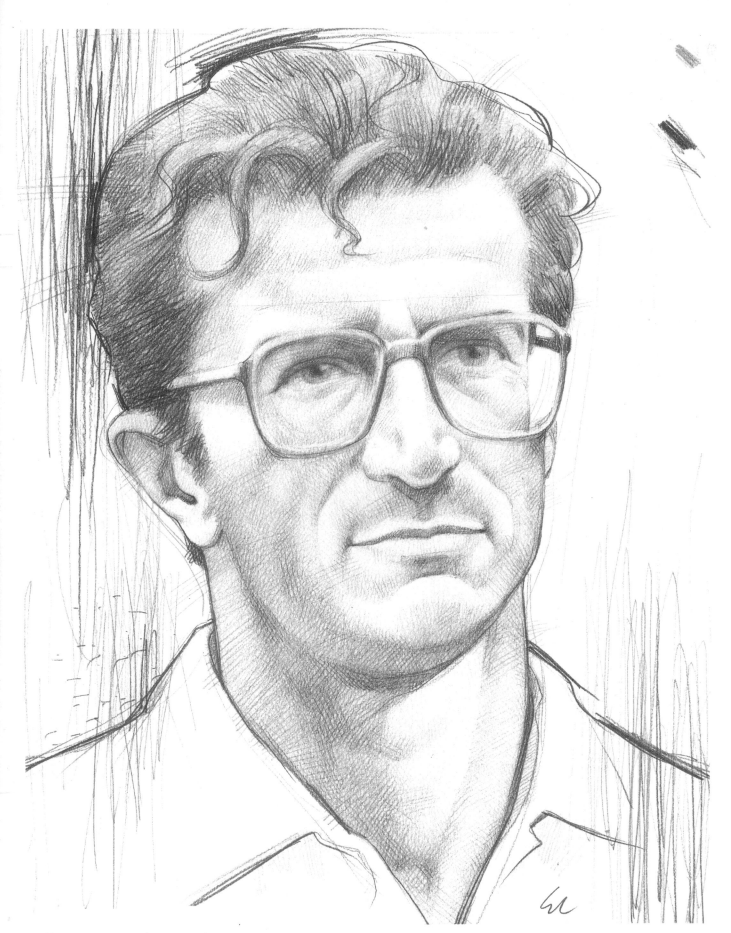

Self-portrait. HB and 2B pencil on paper, 33 x 48cm (13 x 19in).
The one model you can study whenever you like and in any condition is the one you see when you look at yourself in the mirror. Practise drawing your mirror image and don't worry too much if, in the end, you won't be able to recognize yourself fully in that self-portrait. Posing is tiring and, after a short while, your usual expression will look 'drawn' and hard. You could of course, use photographs, as with any other portrait, but if you draw from life the result is more gratifying. Above all try to get the relative proportions of the whole head and then insert the details. Glasses, if worn all the time (as in my case), become part of the physiognomy of the face and can significantly characterize it. Lenses can distort the size and shape of the eyes, enlarging them or making them smaller. Also bear in mind the shadows cast by the frame.

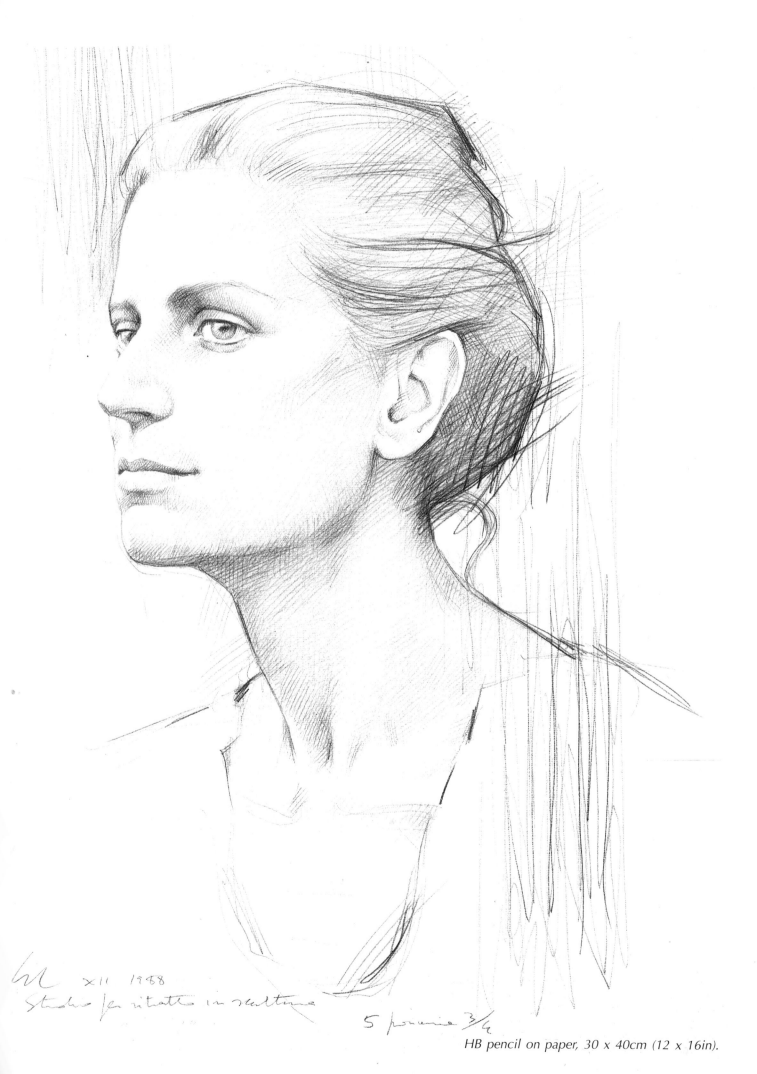

XII 1988

Studio per ritratto in scultura

5 posemine 3/4

HB pencil on paper, 30 x 40cm (12 x 16in).

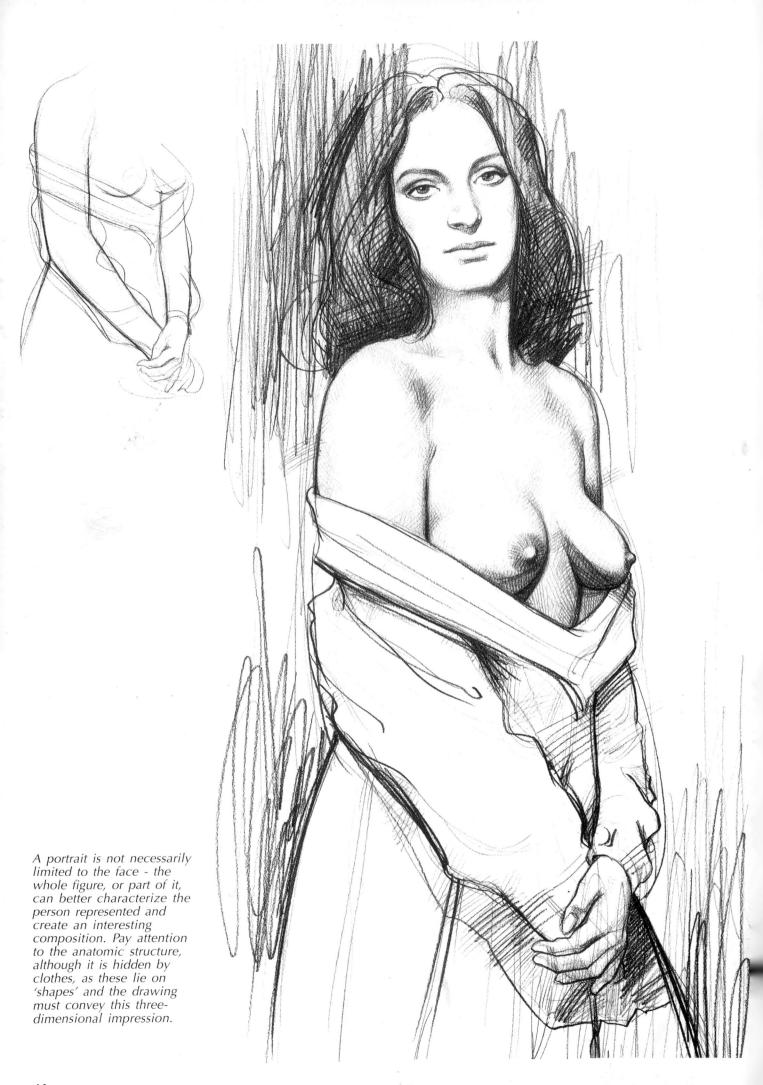

A portrait is not necessarily limited to the face - the whole figure, or part of it, can better characterize the person represented and create an interesting composition. Pay attention to the anatomic structure, although it is hidden by clothes, as these lie on 'shapes' and the drawing must convey this three-dimensional impression.

46

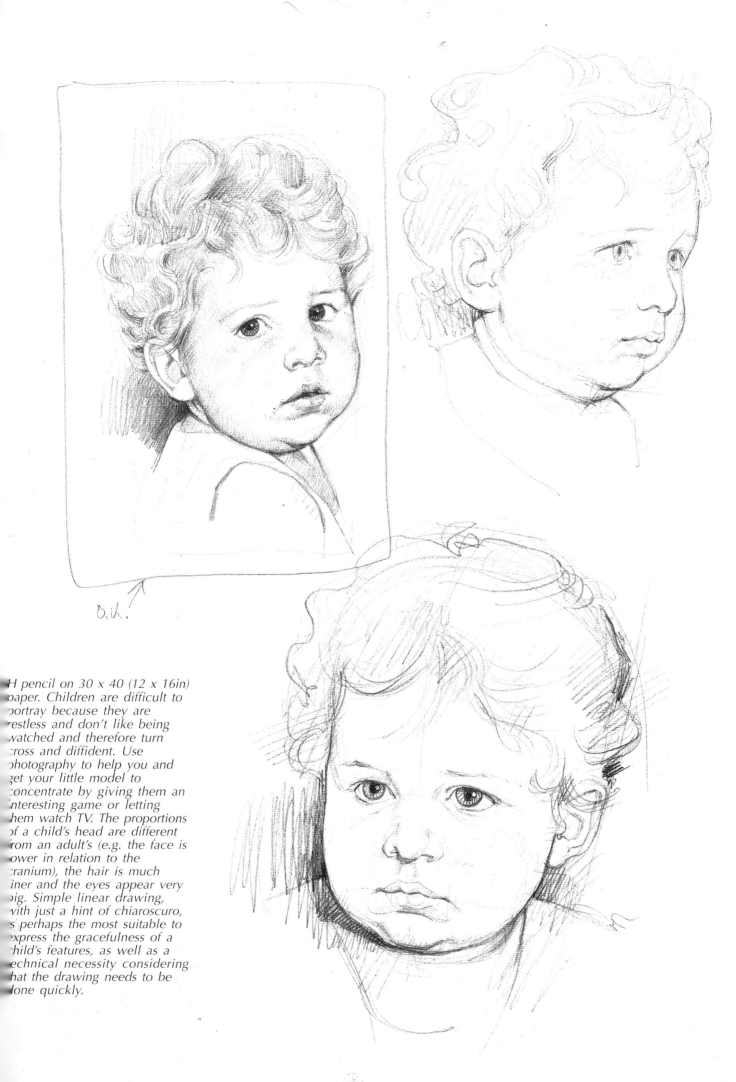

D.K.

H pencil on 30 x 40 (12 x 16in) paper. Children are difficult to portray because they are restless and don't like being watched and therefore turn cross and diffident. Use photography to help you and get your little model to concentrate by giving them an interesting game or letting them watch TV. The proportions of a child's head are different from an adult's (e.g. the face is lower in relation to the cranium), the hair is much finer and the eyes appear very big. Simple linear drawing, with just a hint of chiaroscuro, is perhaps the most suitable to express the gracefulness of a child's features, as well as a technical necessity considering that the drawing needs to be done quickly.

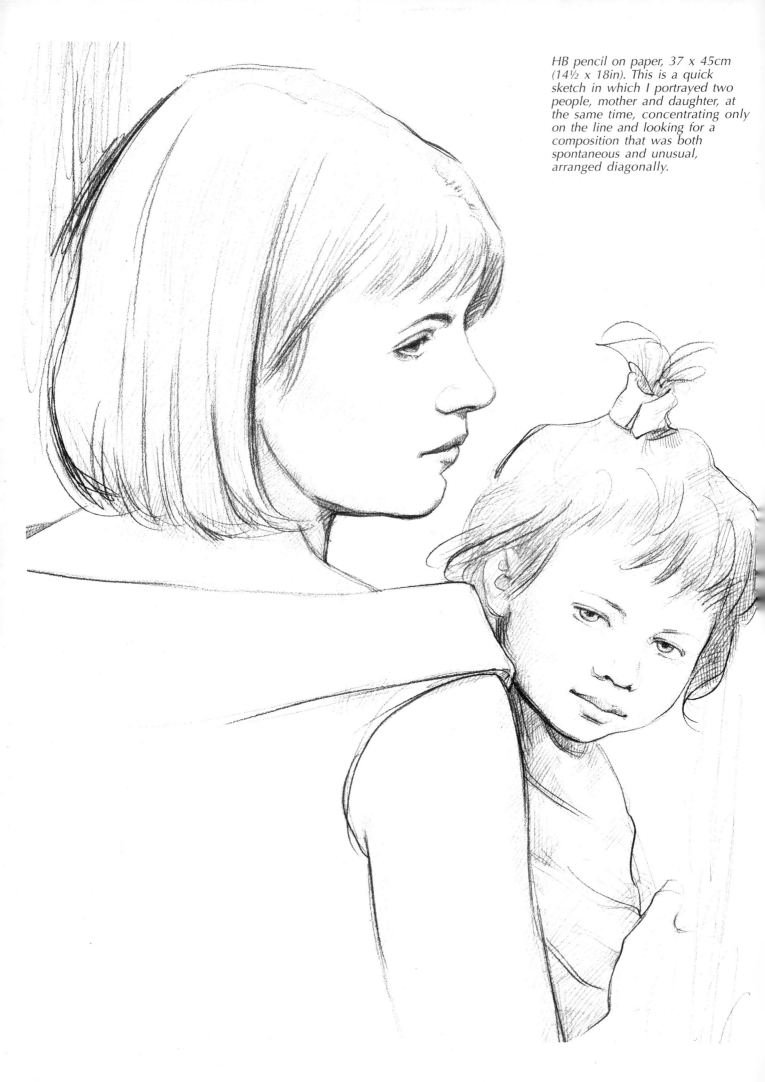

HB pencil on paper, 37 x 45cm (14½ x 18in). This is a quick sketch in which I portrayed two people, mother and daughter, at the same time, concentrating only on the line and looking for a composition that was both spontaneous and unusual, arranged diagonally.

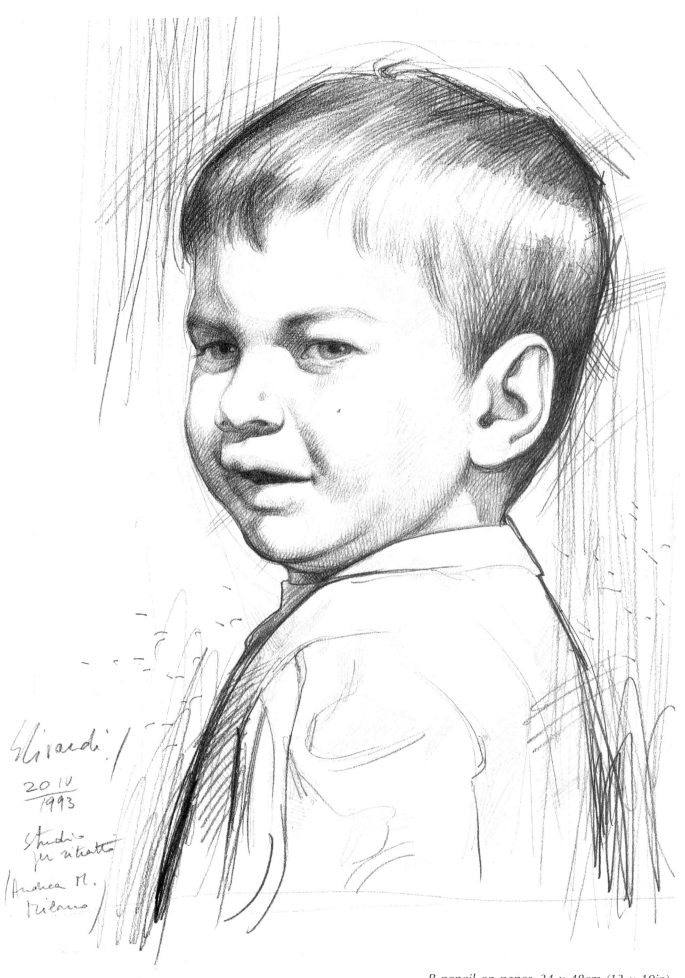

B pencil on paper, 34 x 48cm (13 x 19in).

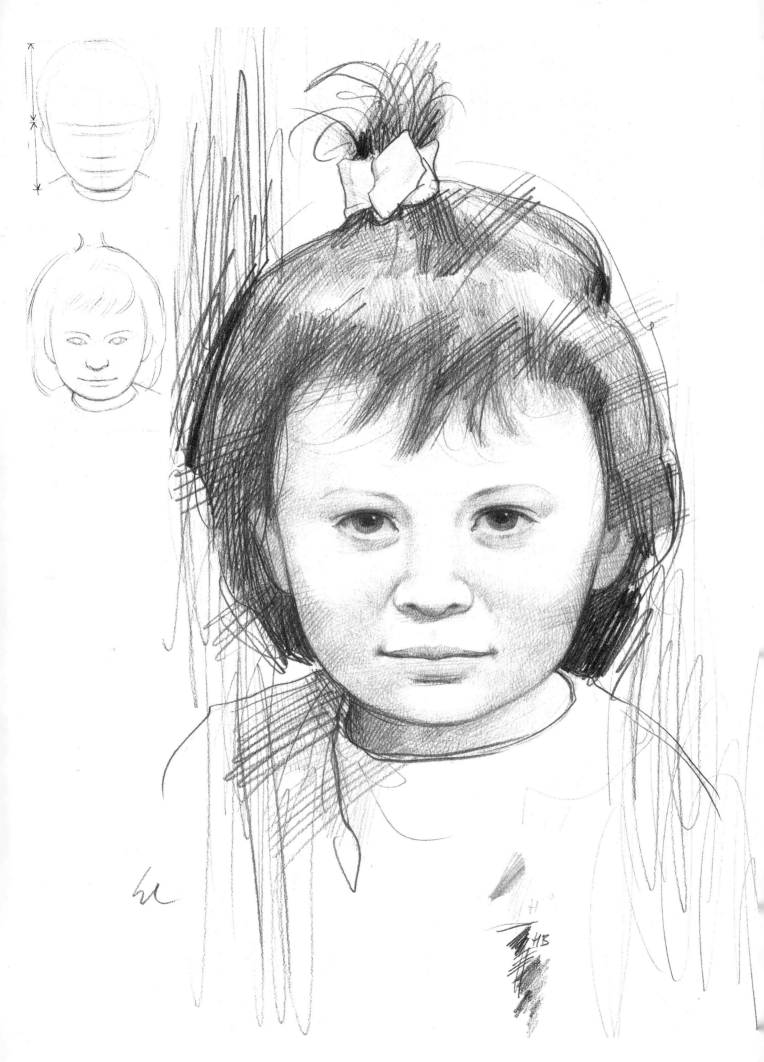

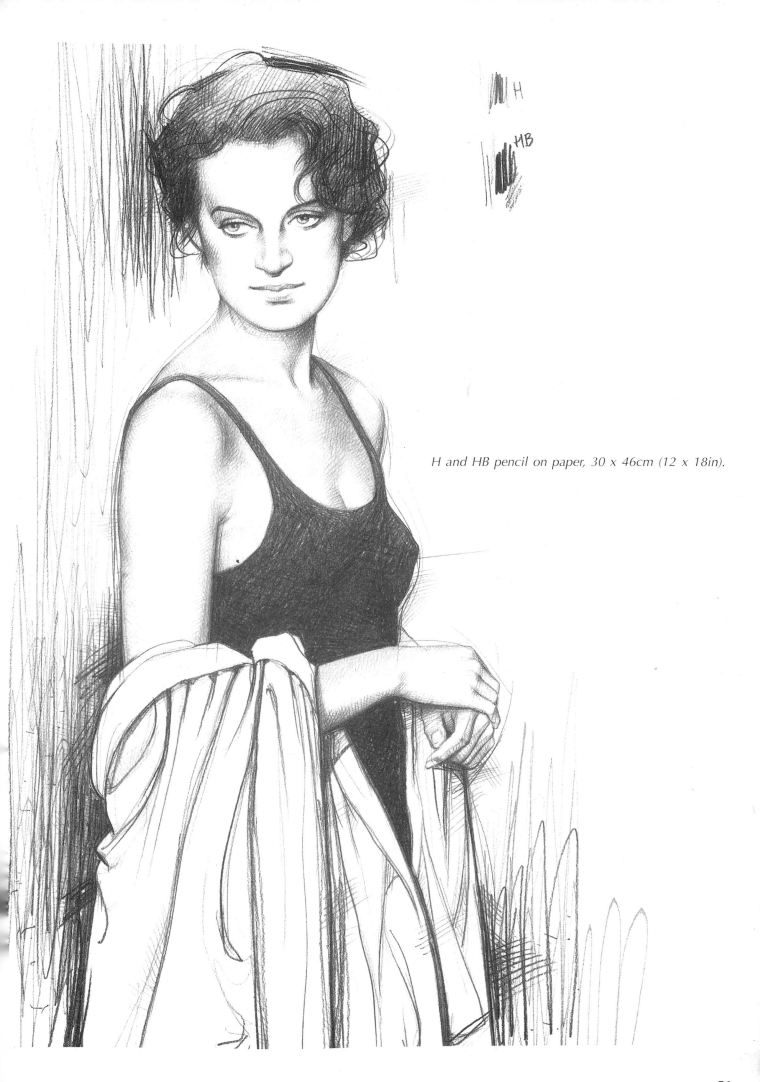

H and HB pencil on paper, 30 x 46cm (12 x 18in).

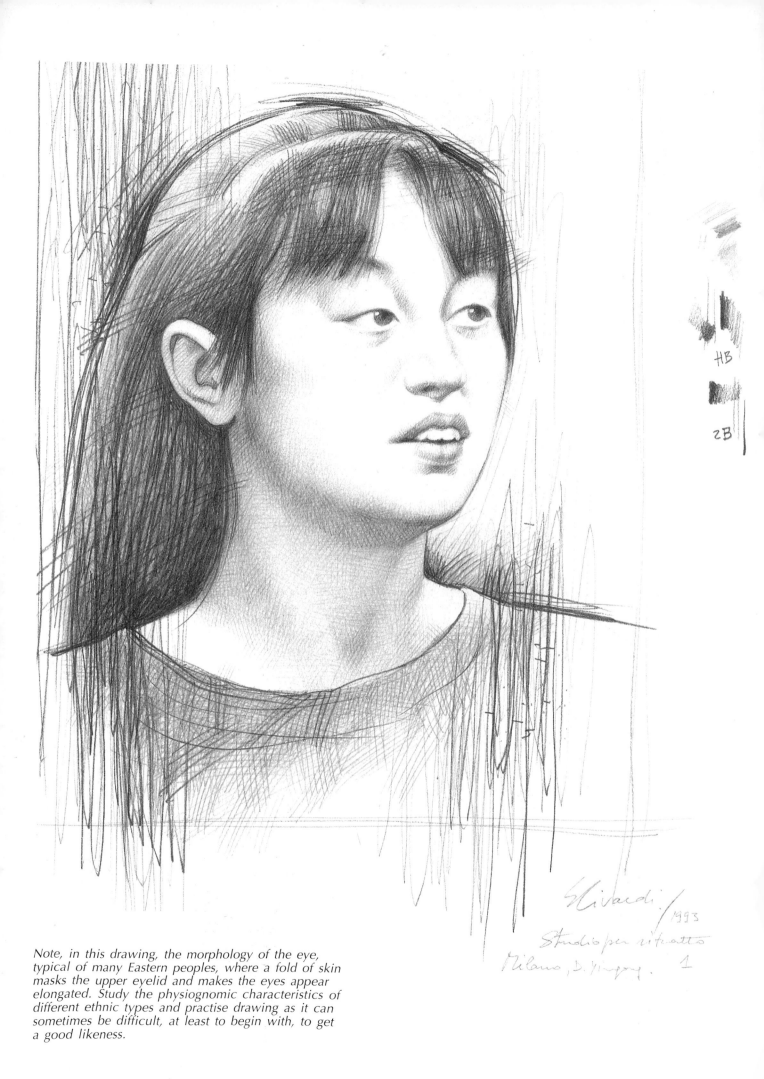

Note, in this drawing, the morphology of the eye,
typical of many Eastern peoples, where a fold of skin
masks the upper eyelid and makes the eyes appear
elongated. Study the physiognomic characteristics of
different ethnic types and practise drawing as it can
sometimes be difficult, at least to begin with, to get
a good likeness.

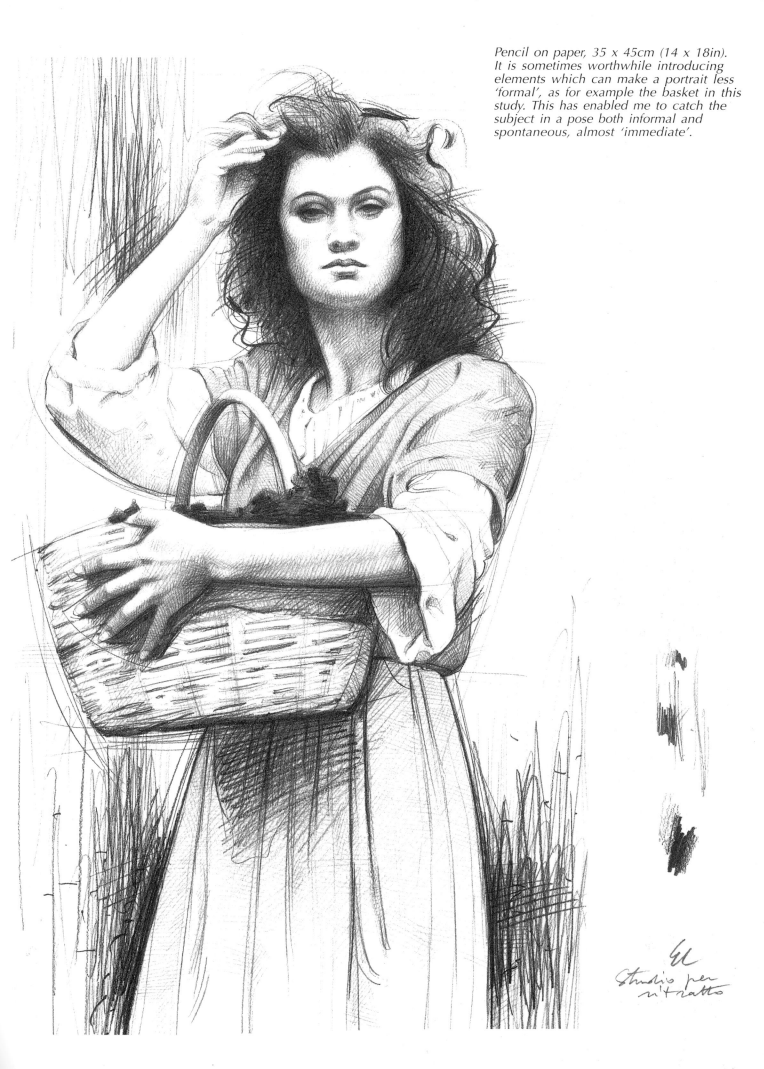

*Pencil on paper, 35 x 45cm (14 x 18in).
It is sometimes worthwhile introducing
elements which can make a portrait less
'formal', as for example the basket in this
study. This has enabled me to catch the
subject in a pose both informal and
spontaneous, almost 'immediate'.*

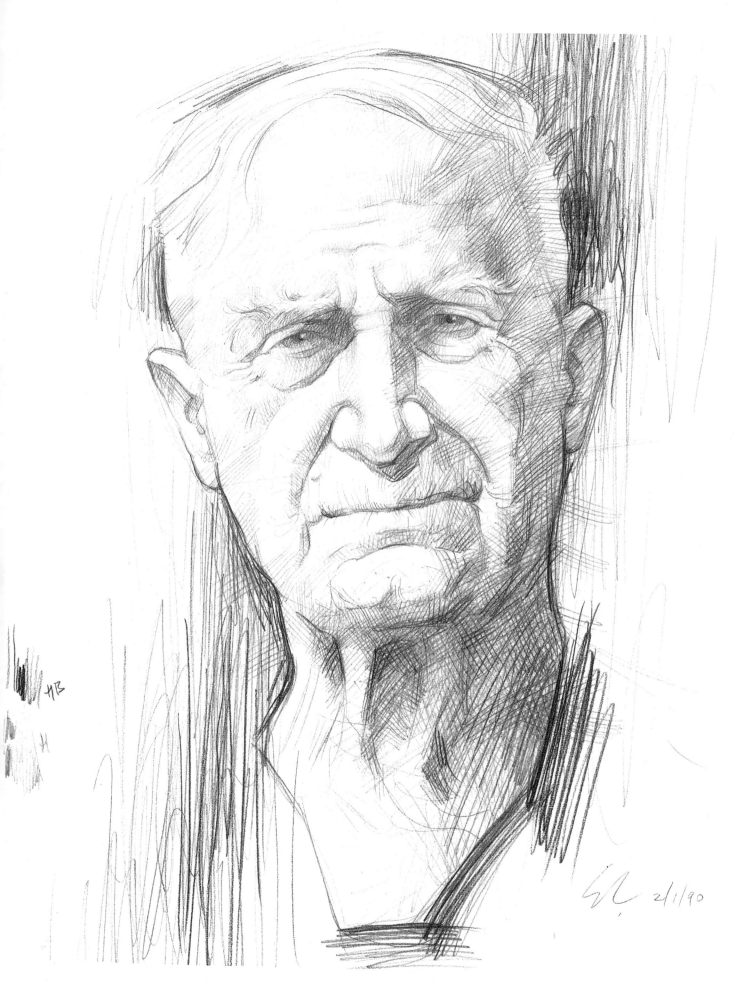

*The drawings on these two pages are studies which I drew from life for a carved
portrait. I walked around the model observing his features from different viewpoints
(you can see the profile on page 58), and I partly neglected the chiaroscuro effects as
I was interested, most of all, in understanding the volumetric structure of the head.*

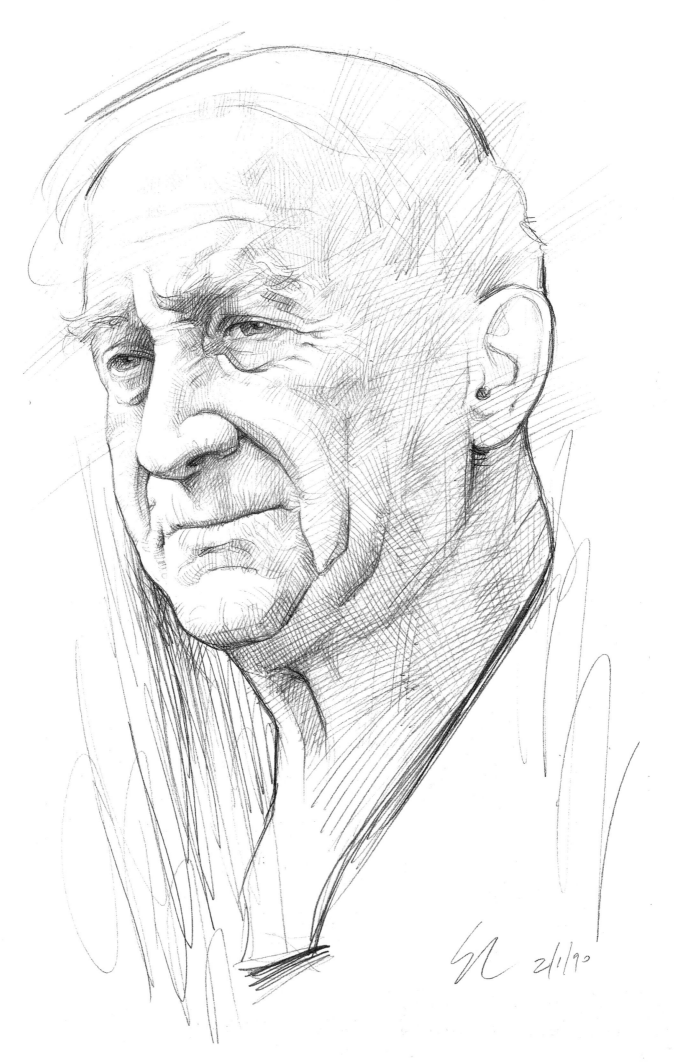

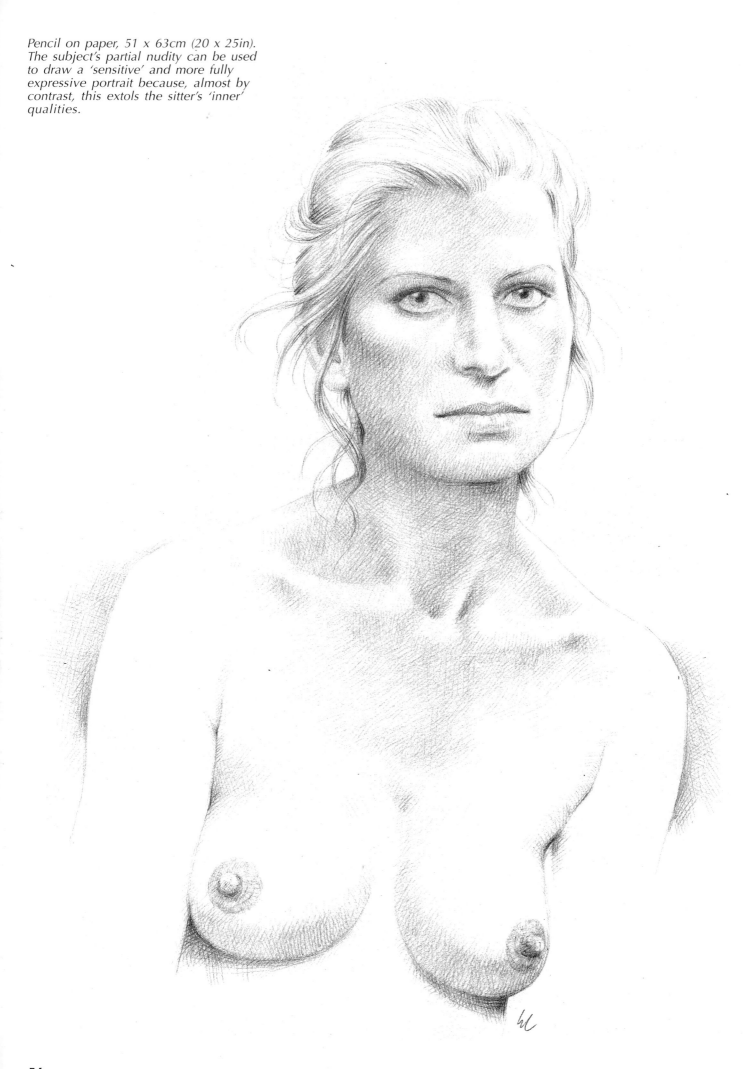

*Pencil on paper, 51 x 63cm (20 x 25in).
The subject's partial nudity can be used
to draw a 'sensitive' and more fully
expressive portrait because, almost by
contrast, this extols the sitter's 'inner'
qualities.*

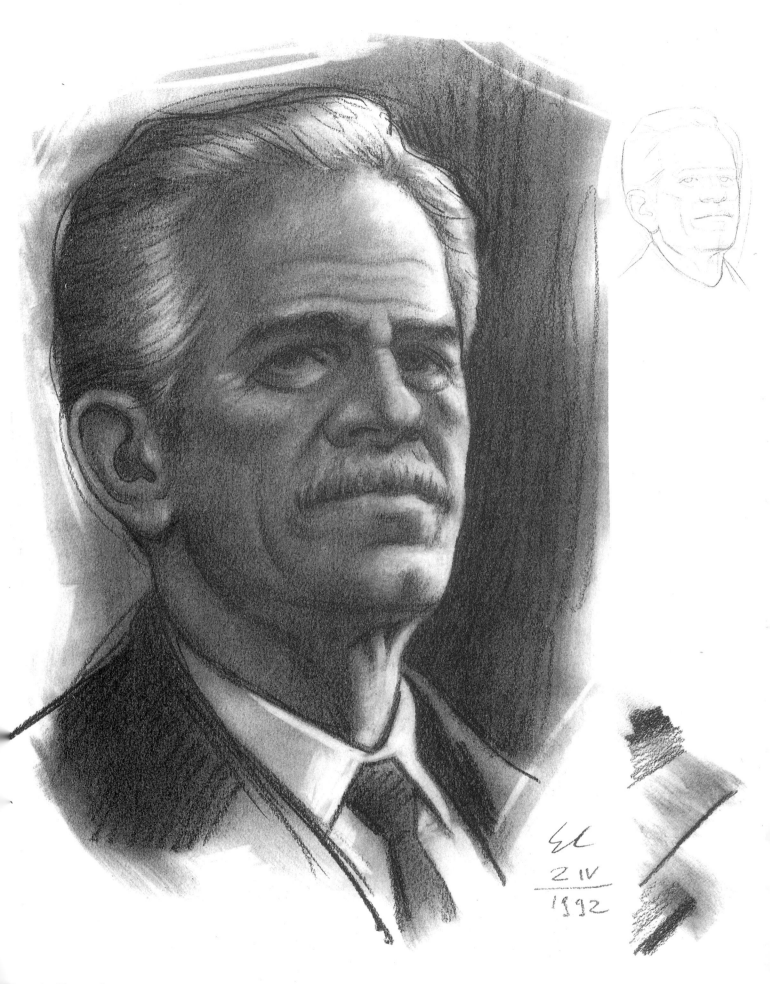

Portrait. Charcoal on paper, 33 x 48cm (13 x 19in).
To draw this study I used weak side lighting as it seemed particularly suited to highlighting the 'severe' character of the subject. The sketch shown on top indicates the basic lines drawn to find the proportions.

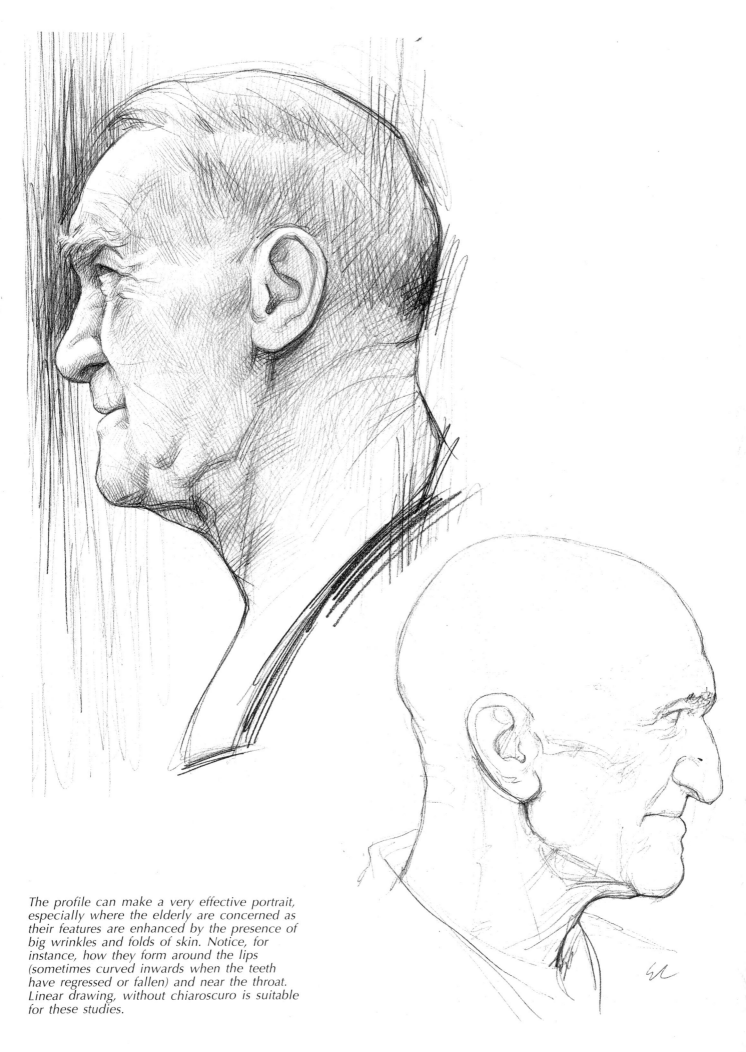

The profile can make a very effective portrait, especially where the elderly are concerned as their features are enhanced by the presence of big wrinkles and folds of skin. Notice, for instance, how they form around the lips (sometimes curved inwards when the teeth have regressed or fallen) and near the throat. Linear drawing, without chiaroscuro is suitable for these studies.

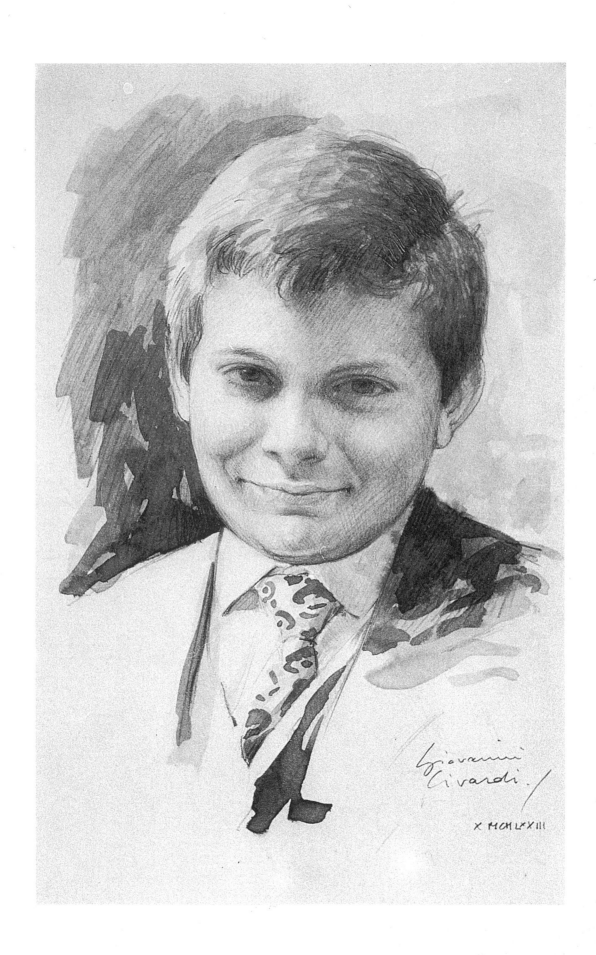

This portrait study was drawn with HB graphite on card, 15 x 20cm (6 x 8in).
I enhanced some shadow areas with water-diluted Indian ink applied with a round
brush. Finally, I 'glazed' the whole surface in order to soften and even the tones.

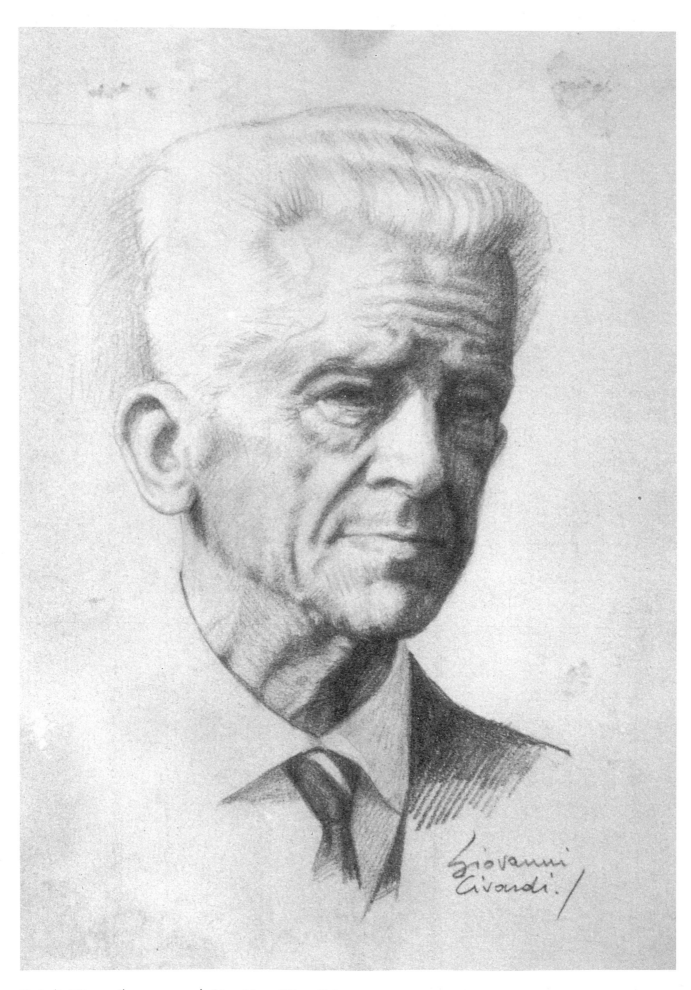

Portrait, HB pencil on grey card, 14 x 18cm (5½ x 7in).

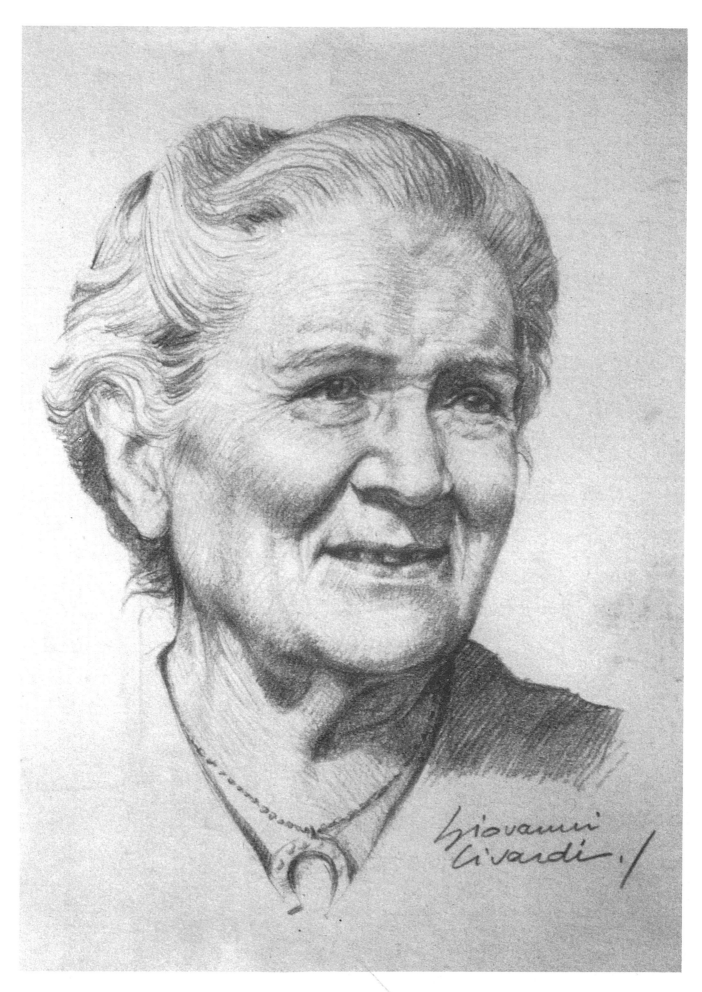

Portrait, HB pencil on grey card, 13½ x 18cm (5 x 7in).

MIXED MEDIA

On these last pages I thought it useful to show some portraits rendered with more complex techniques than those presented in the previous chapters. They can be classified as 'mixed media' (see page 5) and are ideal for evocative and interesting works yet at the same time they leave one free to resort to purely graphic or more markedly pictorial methods to achieve effects which are unusual and very expressive.

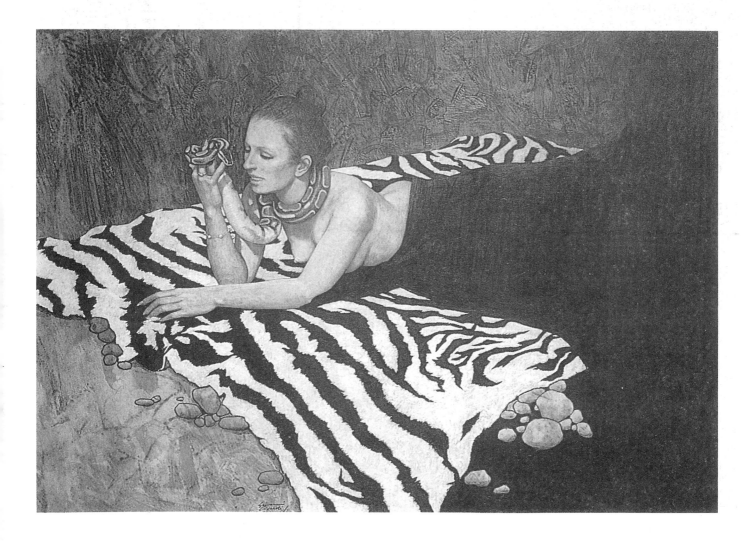

For the drawing you see here (in its entirety on this page while a detail is shown on the next) I have used pen and inks, acrylic colours, pastels, carbon pencils and white tempera on card, 51 x 71cm (20 x 28in). The portrait commissioned was published to illustrate an interview the subject herself gave to a magazine. Knowing it would be used this way I left a large dark area to the right (the dress and the background) to allow the white of the titles and part of the text to stand out.

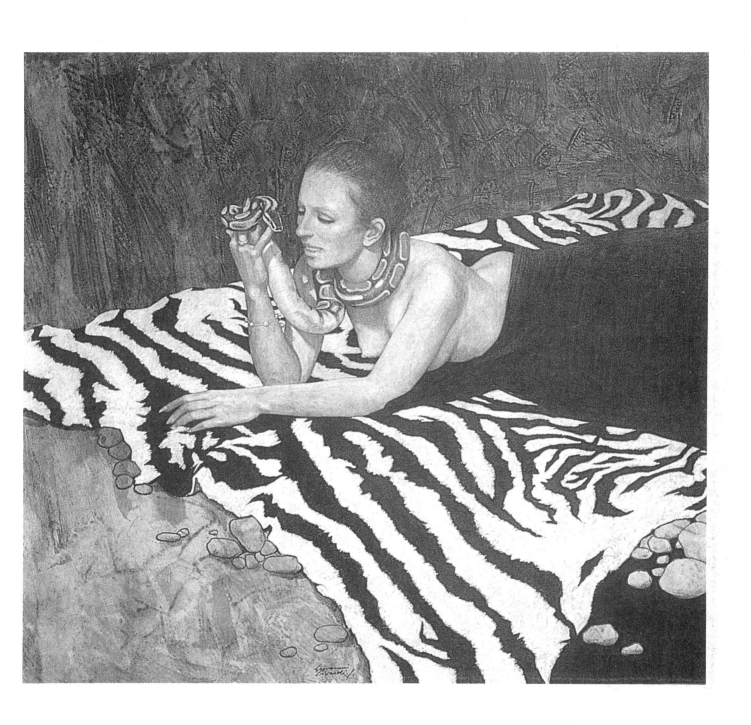

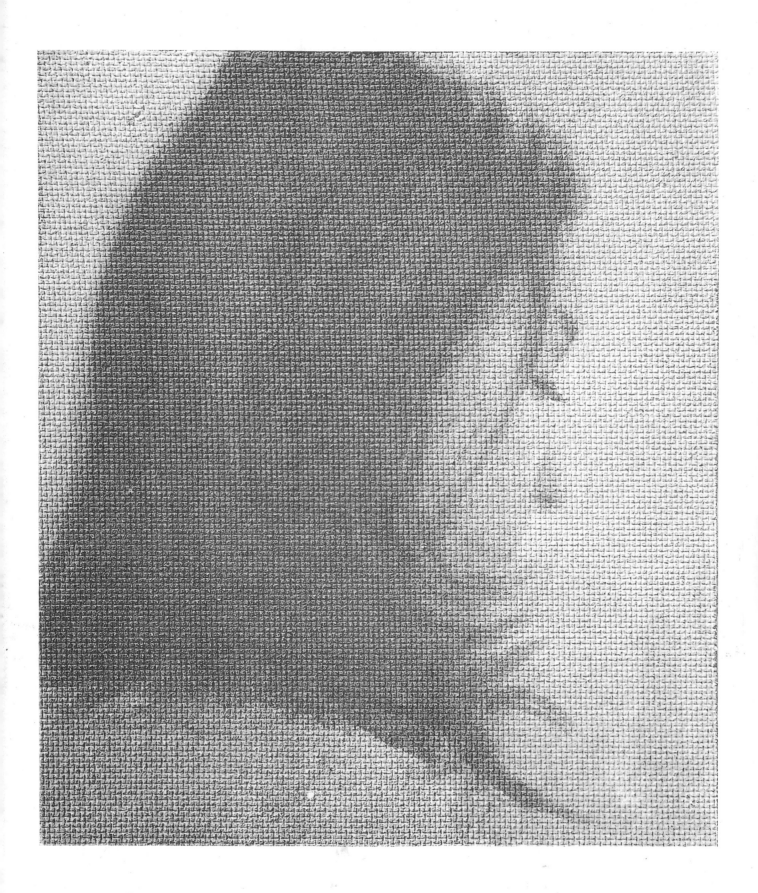

This portrait, where the hair is more prominent than the facial features, is unusual, but is a good likeness, in spite of being almost a back view. It was painted with very diluted acrylic colours on the rough surface of fibre board, 18 x 21cm (7 x 8in), prepared with acrylic chalk.